IMAGES
*of America*

# EARLY
# CUPERTINO

IMAGES
of America

# EARLY CUPERTINO

Mary Lou Lyon

ARCADIA
PUBLISHING

Published by Arcadia Publishing
Charleston SC, Chicago IL, Portsmouth NH, San Francisco CA

Printed in the United States of America

Library of Congress Catalog Card Number: 2006923159

For all general information contact Arcadia Publishing at:
Telephone 843-853-2070
Fax 843-853-0044
E-mail sales@arcadiapublishing.com
For customer service and orders:
Toll-Free 1-888-313-2665

Visit us on the Internet at www.arcadiapublishing.com

# CONTENTS

| | | |
|---|---|---:|
| Acknowledgments | | 6 |
| Introduction | | 7 |
| 1. | How Cupertino Got Its Name | 9 |
| 2. | First Settlers | 13 |
| 3. | Early Businesses in Westside | 21 |
| 4. | Vineyards and Wineries of the 19th Century | 37 |
| 5. | Montebello and Up the Canyon | 49 |
| 6. | Orchards in the 20th Century | 61 |
| 7. | Monta Vista | 77 |
| 8. | Early Schools, Churches, and Organizations | 91 |
| 9. | Early-20th-Century Businesses | 111 |

# ACKNOWLEDGMENTS

The Cupertino Historical Society has thrown open all of their resources, both files on families and photographs, to me in this time of research through the goodwill of past president Donna Austin and the hours of labor from Dwain Dryden. In addition, Audrey Butcher has shared her family's collection of photographs; Laverme (Marcotte) Rabinowitz, the collection of her mother, Henrietta Paviso Marcotte; and Amy Iwagaki Higuchi, her parent's pictures. Paula Quinterno, Gail (Fretwell) Hugger, and Audrey Butcher did some proofreading for historical accuracy.

My adult education classes at the Willows Senior Center endured a fall and winter of Cupertino research and made suggestions for easier understanding—namely, images of the period to better understand relationships. Alicia and Mac Chisholm introduced me to Amy Higuchi and gave me some other leads. Dr. Mike Shea brought me a contact with the first drugstore owner, Clarence Castro.

Finally, Tim Peddy has given hours and days of his time and expertise making copies of the many photographs I dredged up out of the files and from various people, plus taking some field trips for original shots. He has been extremely helpful and patient and has used photographs from this volume as part of the PowerPoint presentations to promote the book. His wife, Barbara, has also been a staunch supporter.

To these and the unnamed folks who wrote up their family histories and included photographs for the museum's files, I am grateful. If I misinterpreted or got it wrong, my apologies.

I would also like to thank my editor, Hannah Clayborn, for her assistance and extreme patience as we went on and on through some difficult health problems that took precedence over researching and writing.

—Mary Lou Lyon

# INTRODUCTION

We know from historical sources that there were many Native Americans in our area, hunting, fishing, and gathering the abundant foodstuffs found here. However, there has never been an authenticated "dig" within the extended boundaries of Cupertino, although a Native American skeleton was once found on the Painless Parker Ranch and their grinding rocks and weapons were found on the Fremont Older Ranch. Only one reference mentions two American Indian men who had cabins on the Bordi property up the canyon in modern times. Since the original Indians' dwellings were not permanent like ours, but seasonal, it is possible that signs of a settlement might someday come to light.

Once Mission Santa Clara was established, nearly all of the indigenous people were drawn to it. This area was, no doubt, used as grazing land for some of the mission's livestock. Some parts of the area were parts of Mexican land grants Quito Rancho and San Antonio Rancho. The bulk of the Cupertino area fell into the realm of "government land," which was available for homesteading.

Most of the homesteaders in the Cupertino area were men with large families who pitched in to help with the work as they grew old enough, and that included chores for some very small folks; even preschool-aged children could be sent to gather eggs. Most had no hired help, or if they did, it was for harvesting or clearing the land only. They may have called upon the large Chinese colony in San Jose for that help, but only one record refers to using the Chinese labor in the fields, and no photographs have been found. The single mention of the Chinese workers is in the J. D. Williams story, in which a work party from Chinatown was enlisted to help clear away the underbrush so the area could be planted with grapes. Part of the underbrush they were burning included poison oak, which the Chinese were not familiar with. The itching, swollen, red, infected members had to be sent back to Chinatown for treatment, and some nearly died.

Early settlers saw the rich earth of the area and planted wheat, competing on the world market for this product. They also pastured livestock and raised hay before clearing the brush away and planting large acreages of wine grapes. The West Valley area was covered with vineyards and wineries in the late 1800s. Many competed at various world fairs and expositions and brought home ribbons. There was also at least one Irishman's distillery, making whiskey from grain. When the phylloxera, a plant louse that attacked and killed the grapes, hit the area about 1900, nearly all replanted with orchards of prunes, apricots, peaches, and pears.

The passing of the nationwide prohibition of alcoholic beverages after World War I did not encourage replanting of grapes, although a few persisted, making wine for "personal" use. A long and profitable time of planting, harvesting, drying, and canning of fruit throughout the valley began. Many visitors came to the area at blossom time to the "Valley of Heart's Delight" festivals, and transportation to accommodate these visitors sprang up in some cities. Drying and canning as a means of processing fruit replaced the many wineries and remained the dominant industry until after World War II, when the housing boom began and, much later, the dot-com industry took over.

The orchards were replaced by, at first, modest houses for workers, then as the computer age began, with larger houses, followed by the dot-com explosion, which brought obscenely large houses to many areas and made the land too valuable for agriculture to exist. So the age of agriculture has passed but is still mourned. Orchards were torn out and replaced by housing and concrete. Drying yards and canneries were torn out and replaced by light industry. The complexion of the area was forever changed. "The Valley of Heart's Delight" was no more.

# One

# HOW CUPERTINO GOT ITS NAME

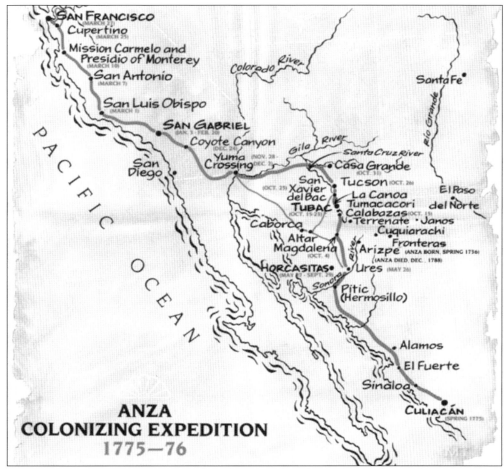

Juan Bautista de Anza was a frontier soldier and the commander of the Presidio of Tubac, which today is in southern Arizona. In 1772, he petitioned the viceroy of New Spain, Antonio Maria Bucareli y Ursula, for permission to explore and develop a land route from Sonora to California. On January 7, 1774, he and Fr. Francisco Garces left Tubac with 20 soldiers to find the route. He finally received permission to take settlers overland to California, explore the Bay of San Francisco, and select sites for two missions and a presidio there. Thirty families, including 10 veteran soldiers and a total of 240 persons, were led by Anza with Ensign Don Joseph Joachin Moraga as second in command. There were 39 adult males, 34 adult females, 70 boys, and 50 girls, with 44 of the children under 10 years of age. The group also included Fr. Pedro Font, who kept a diary and made maps, including the one pictured here. (Courtesy Southwest Parks Association.)

When they reached Monterey, Gov. Fernando Rivera would not allow Anza to continue with the settlers, so Anza with Father Font, 11 muleteers, and servants—a party of 20—continued north to explore around San Francisco Bay and choose the sites for the missions, the Presidio, and Pueblo San Jose. (Courtesy Southwest Parks Association.)

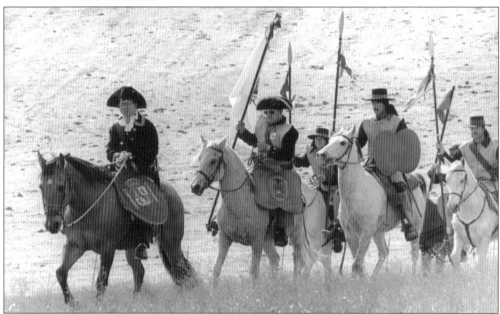

The following selection comes from Anza's diary: "Monday, March 25, 1776 . . . After traveling a short distance in the plain we turned to the west-northwest, and then began to meet many heathen, who went notifying those ahead, greedy for the glass beads which I gave them. . . . we turned to the west, going close to some small hills to our left, and arrived at the arroyo of San Joseph Cupertino. . . . Here we halted for the night." Pictured here, from left to right, are reenactors Paul Bernal, Hamilton Ryder, Joe Adamo, Pedro Cole, and Gary Genistra. (Courtesy Mary Lou Lyon.)

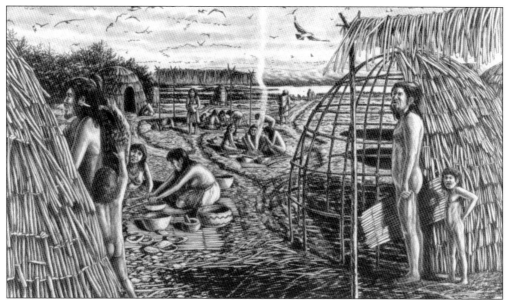

Anza continues in his diary: "[Father Font] said Mass. We set out from Arroyo de las Llagas at quarter to eight in the morning, and at four in the afternoon halted at the Arroyo of San Joseph Cupertino. . . . Along the way many Indians came out to us. On seeing us they shouted amongst the oaks and then came out naked like fawns, running and shouting and making many gestures, as if they wished to stop us, and signaling to us that we must not go forward. Although they came armed with bows and arrows, they committed no hostility toward us. . . . I think that I must have seen more than a hundred Indians." This illustration by Michael Harney appears in *The Ohlone Way* by Malcolm Margolin.

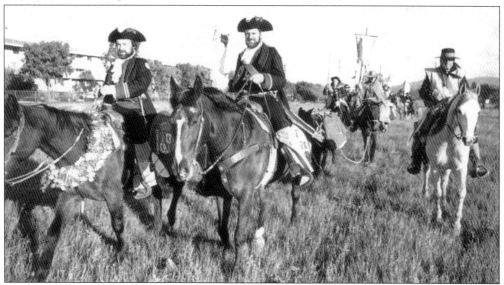

When the party came to what today is called Stevens Creek, members decided to name it for St. Giuseppe of Cupertino, Italy, Father Font's patron saint. They left a heavy lead plate, 6-by-12 inches, with the name and date on it in ancient Spanish. This plate was discovered by Charles Rousten when cleaning up the area around Las Palmas Winery and Stevens Creek for John T. Doyle after the great earthquake of 1906. (Courtesy Cupertino Historical Society.)

Sue A. Corpstein is flanked by former students from San Antonio School, Louis Stocklmeir, Lizzie Snyder (Forbes), Irene Smith (Carter), and Carl Schoppe. Charles Rousten hailed Corpstein as she drove to school in 1906. She cleaned up the lead plate and made out "St. Joseph of Cupertino," "Juan Bautista de Anza," and "March 25, 1776." Rousten did not take it to Santa Clara University to get it translated, and it was lost again. (Courtesy Cupertino Historical Society.)

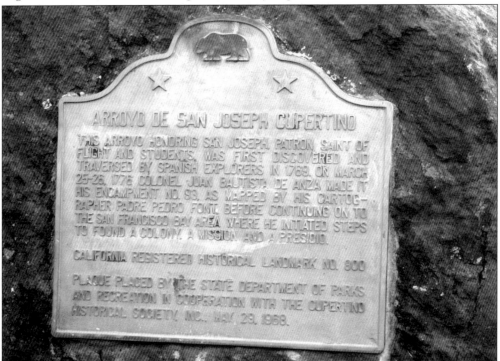

Cupertino historians applied for a state marker. California State Historical Marker No. 800, commemorating the Anza party camp site, was placed on a large boulder in the student parking lot at Monta Vista High School in 1964. (Courtesy Tim Peddy.)

# Two
# FIRST SETTLERS

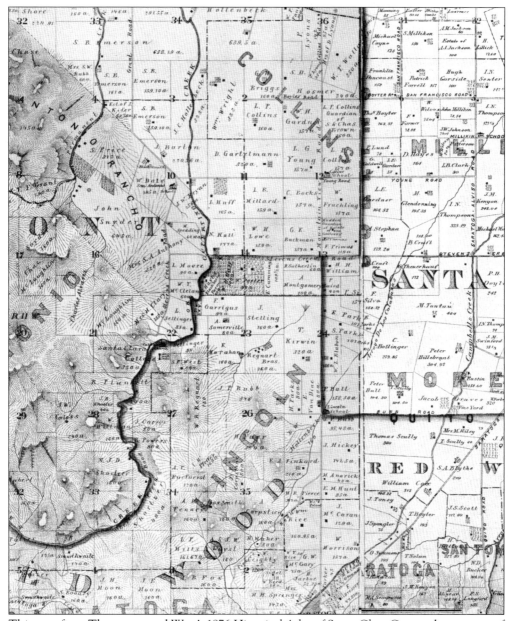

This map from Thompson and West's 1876 *Historical Atlas of Santa Clara County* shows many of the early settlements. Elisha Stephens was gone by then, so his property appears as McClellan. Note the elevations, the streams, and the relationships between the different properties.

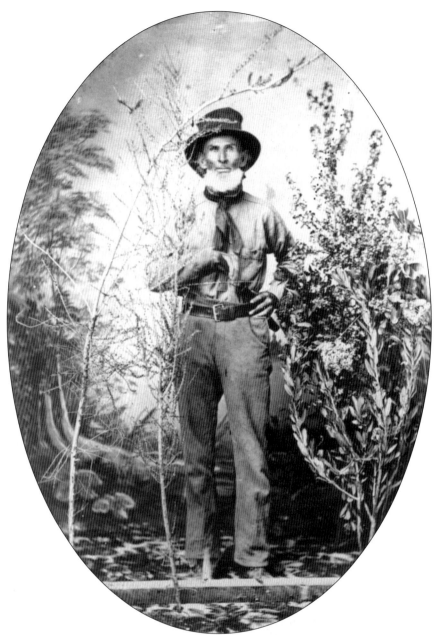

Capt. Elisha Stephens (1804–1887) of the Stephens-Murphy-Townsend Party of 1844 was the first to cross over the Sierra Nevada with wagons, two years before the Donner Party. They arrived with two more souls than they had started with, and no one died. He called the pass over the Sierra summit Truckee, but today it is known as Donner Pass. Stephens was the first American to homestead 160 acres of government land in Westside on the bend in Stevens Creek. He later bought 155.57 acres from Rancho San Antonio for $855, making his farm 315.57 acres. He planted four acres of mission grapes and the blackberries that lent their name to the property, Blackberry Farm. He also had an orchard and pastureland, becoming the first farmer, vintner, and orchardist in the area. His favorite food was chicken-fried rattlesnake. (Courtesy Cupertino Historical Society.)

The plaque honoring Capt. Elisha Stephens at the Blackberry Farm Nine Hole Golf Course was dedicated in 1995. The road, creek, and reservoir named for Stephens are all misspelled as "Stevens." When the captain signed the register at Fort Laramie on his way west, he signed it "Elisha Stephens." In 1864, the area had become too crowded for him, so he sold it to W. T. McClellan and George McCauley, moving to Kern County, where he was a pioneer settler. (Courtesy Tim Peddy.)

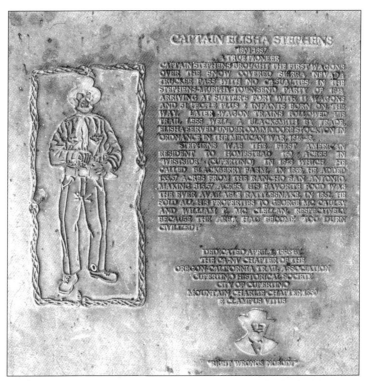

Mr. and Mrs. W. M. McClellan and family came from St. Louis, Missouri, to California in 1849. They purchased half the land holdings of Captain Stephens in 1862, but the deed was not recorded until December 22, 1864, because Stephens had not bothered to drive into the county courthouse to register his deed. He registered it from Kern County at the insistence of McClellan. Pictured here is McClellan Ranch Park on the former Stephens property. (Courtesy Tim Peddy.)

The McClellans established the first West Valley Subscription School in 1864. The schoolmistress boarded at their house. In 1878, William and his neighbors petitioned the county board of supervisors to have the old wagon road through his ranch declared a county road. Today 18.5 acres is a nature and rural preserve, including three barns, a blacksmith shop, a ranch house, and two pump houses.

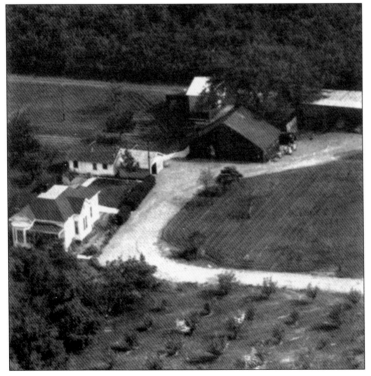

In 1850, Robert Glendenning came to West Side from Scotland, by way of Australia, where he met and married Margaret Howie. They sailed immediately for gold rush San Francisco. He purchased squatter's rights to land, living in a tent with his foodstuffs in a board shed while clearing the land. After building a house and planting crops, he discovered he owed the owners of Rancho Quito $30 an acre for 200 acres. (Courtesy Cupertino Historical Society, Glendenning files.)

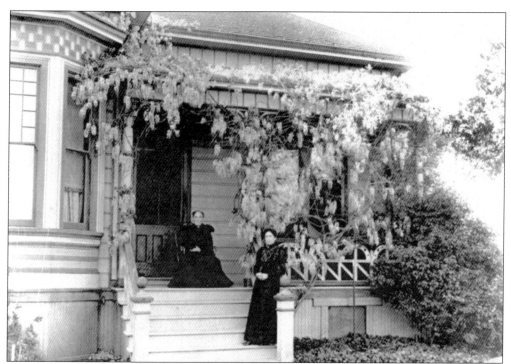

Glendenning's widow, Margaret, finished the payments after his death in 1868. Half of the property was given to Margaret, who built this house in 1889 on 80 acres on the south side of the property, and the other was divided among their children in 1884. The land along Homestead Road (Young Road) was given out, east to west, 16 acres each, to Mary, Margaret C., Ellen, Joe, Jim, and George. (Courtesy Cupertino Historical Society, Glendenning files.)

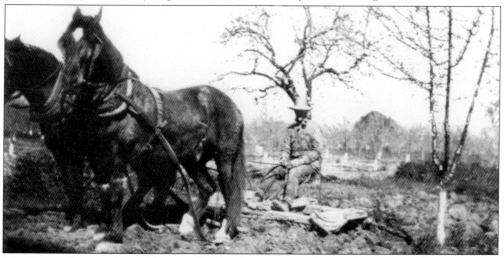

John Leonard, son-in-law of Margaret C. Glendenning Burrell, built the barn on the Glendenning property about 1916 and redid the ranch headquarters about 1944 or 1945. John and his wife, Grace, had one child, Burrell Leonard, born January 12, 1911. Burrell attended local schools and graduated from Stanford University. He worked with his father in maintaining their fruit ranch. They sold their apricots to Gerber Baby Food. (Courtesy Cupertino Historical Society, Glendenning and Leonard files.)

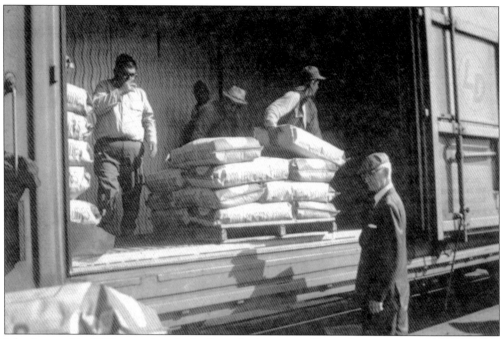

John Leonard in 1927 supervises the loading of a shipment of bagged prunes into a rail car headed for the East Coast. (Courtesy Cupertino Historical Society, Glendenning and Leonard files.)

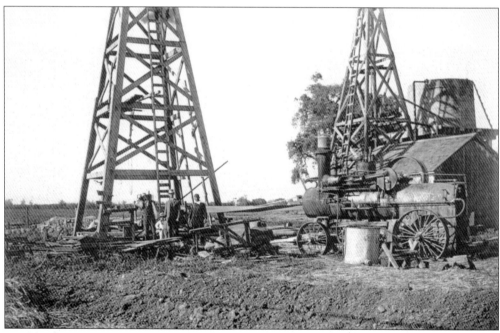

Joe Glendenning, Burrell Leonard, and John Leonard are pictured at a new well in 1915 that augmented the 1890 well. The new well pumped until 1920, when the declining water table put it out of business. Gasoline pumps replaced the 40-foot windmill in 1907. (Courtesy Cupertino Historical Society, Glendenning and Leonard files.)

Burrell Leonard sold 100 acres to Varian in 1964, negotiating rezoning. Cupertino had incorporated in 1955, and the new freeways and expressways nearby made the area a desirable place for their companies. Varian sold 46 acres to Hewlett-Packard (HP) for their Cupertino site in 1968 and 50 acres in 1971. Leonard and other farmers also built Vallco Fashion Park. (Courtesy Cupertino Historical Society, Glendenning and Leonard files.)

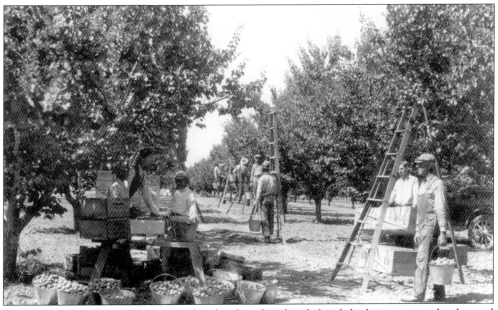

Eleven apricot pickers in the Leonard orchard are lined up behind the horse cart with a lug and buckets full of apricots in front. Note the patient horse in this c. 1926 image. (Courtesy Cupertino Historical Society, Glendenning and Leonard files.)

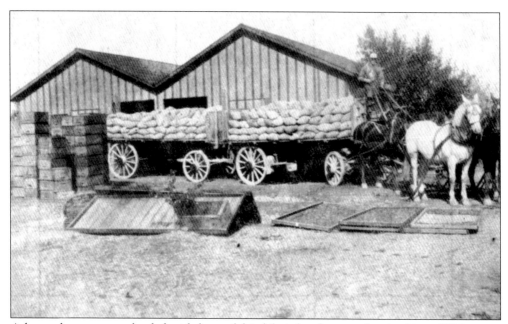

A horse-drawn wagon loaded with bags of dried fruit heads to market in this c. 1926 image. Behind the truck are piled boxes used to bring the fruit from the orchard to the canneries or dry yards. In front are some drying trays. (Courtesy Cupertino Historical Society, Glendenning and Leonard files.)

Beez Glendenning Jones is pictured in front of the Glendenning Barn at its dedication on March 5, 2004. HP has kept the barn, the pump house, and the windmill tower, using the area for a picnic site, but they bulldozed the house in 1973. The first employees in the new buildings called themselves "The Apricot Division." (Courtesy Mary Lou Lyon.)

# *Three*
# EARLY BUSINESSES IN WESTSIDE

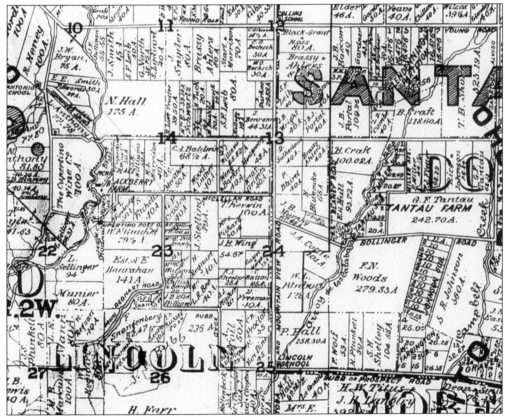

This 1890 map of Cupertino Corners shows many of the early settlers and businessmen's properties. In the center above, Collins School is visible. Near the bottom of Mountain View Road, Lincoln School is on Prospect Road. The picnic area of Blackberry Farm is next to Stevens Creek, with the Cupertino Wine Company on the left and Campbell Creek on the right. This map takes in Foothill Boulevard from the west, Campbell Creek from the east, Young (Homestead) Road from the north, and Prospect Road from the south. (Courtesy Cupertino Historical Society.)

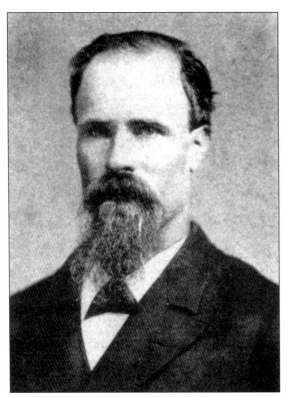

Born in Ireland in 1840, Alexander Montgomery came to Westside in 1868, purchasing 40 acres of land on Sunnyvale-Saratoga Road. In 1870, he planted and harvested his first successful crop of wheat. In 1874, Montgomery purchased an additional 100 acres bounded by Stevens Creek Road, McClellan Road, Stelling Road, and Sunnyvale-Saratoga Road for $5,000 at $50 an acre. (Courtesy Cupertino Historical Society.)

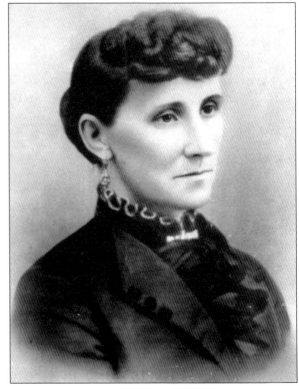

Alexander Montgomery married Mary Jane McIrrath, also from Ireland, and moved into his first modest home on the corner of Stevens Creek Road and Sunnyvale-Saratoga Roads. He was an enthusiastic buggy racer, raised greyhounds, and owned eight peacocks, which strutted about under the oaks. (Courtesy Cupertino Historical Society.)

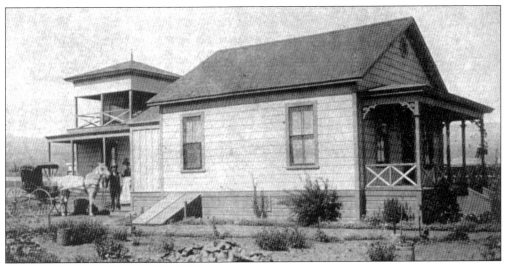

This was the first house for Alexander Montgomery, later owned by Arch Wilson and James Knox Polk Dixon. Montgomery moved into the new two-story Victorian that had a zinc bathtub, an elegantly styled cupola-roofed dining room with a huge stove, a parlor, five bedrooms, and a special room called the William McKinley Room, which was kept ready, with tiger and bearskin rugs, in case his "beloved president" ever came to call. (Courtesy Cupertino Historical Society, Montgomery files.)

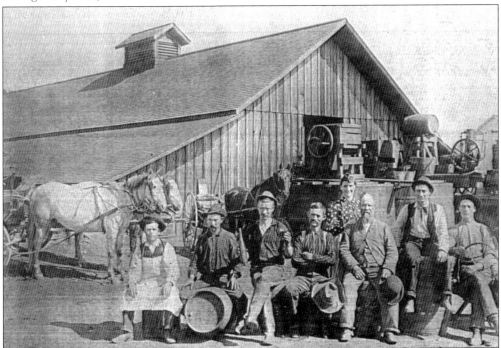

In his distillery, 500 feet from the house, Alexander Montgomery (pictured fifth from the left) produced whiskey from his grain, several types of wines, including plum wine and kosher sacramental wines for the Jewish communities, and brandies. Like others in the area, the phylloxera (a parasitic plant louse) destroyed his vineyards in 1900. At that time, he converted his lands to fruit orchards. (Courtesy Cupertino Historical Society, Montgomery files.)

23

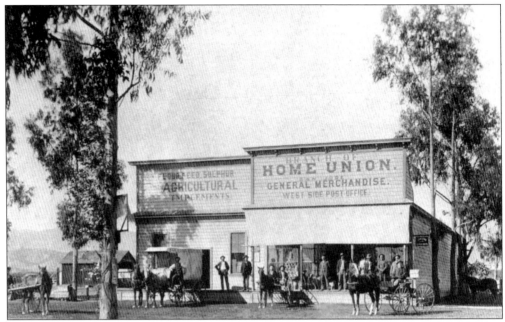

In 1892, Alexander Montgomery had Enoch Parrish construct the West Side Branch of the San Jose Home Union Store building. Montgomery became the first postmaster when he opened the store. It sold everything that people did not raise for themselves—groceries, wood, coal, coal oil, pots, pans, feed for livestock and poultry—and was truly a one-stop shop. (Courtesy Cupertino Historical Society, Montgomery files.)

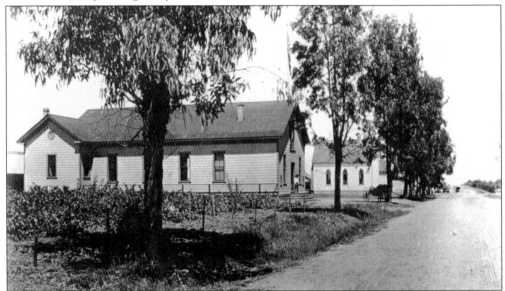

Montgomery gave an acre each to the Horticulture-Viticulture Association, the Union Church of Cupertino (both shown here), and St. Joseph of Cupertino. He attended the Union Church of Cupertino, often wearing a skull cap to keep the flies off his bald head. Sometimes he would drive his carriage beside an open window of the church and listen to the sermon from there. He would often comment on the minister's sermon, either bad or "damn fine." (Courtesy Cupertino Historical Society.)

Since the Montgomerys had no children, he sent for his nephew, Arch Wilson, in 1902. Arch became half partner of the Home Union Store, inheriting the traditions of his uncle as well as his property. In 1904, Arch married a pretty, young schoolteacher of the first Doyle school, Pauline Grove. The young couple moved into Uncle Alex's first home, where their children, Pauline and Warren, were born. (Courtesy Cupertino Historical Society, Montgomery files.)

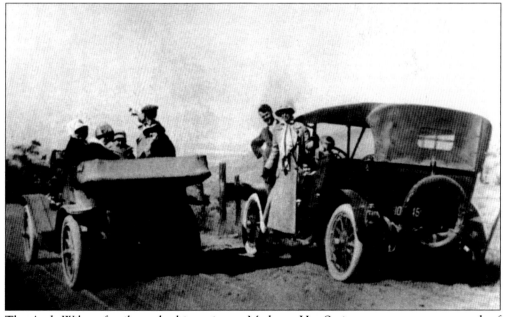

The Arch Wilson family made this outing to Madrone Hot Springs, a summer resort north of Gilroy, in the old Buick in 1914. (Courtesy Cupertino Historical Society, Montgomery files.)

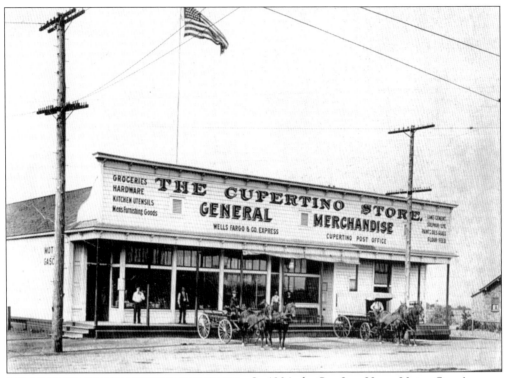

In 1904, the San Jose Home Union Store's name was changed to Cupertino Store, Inc., and it moved to the northeast corner of Cupertino Corners to allow for the interurban tracks. It was the hub of the little town. Arch Wilson was the store's president and the postmaster. By 1905, the mail was delivered to him by the Peninsular Interurban Railroad. When the farmer's crops were not doing well, he extended credit to them until conditions improved. (Courtesy Cupertino Historical Society, Montgomery files.)

James Knox Polk Dixon worked in the San Francisco Mint until Benjamin Harrison's election in 1890. He became the first manager of the San Jose Home Union Store and the notary public in 1892. He was paid $80 a month to sell everything from groceries and hardware to fertilizers and explosives. Mamie Dixon, his wife, opened the West Side Book Club in 1900. For a small weekly fee, members could enjoy light fiction, semi-historical novels, history books, and travelogues. (Courtesy Cupertino Historical Society, Dixon files.)

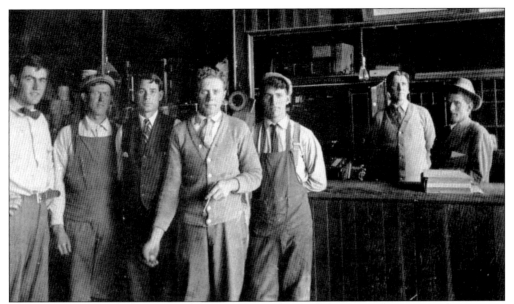

These clerks pictured in the Cupertino Store in 1916 are, from left to right, Harold Dixon, Claude Parrish, Billy Calvert, Cornelius McCarthy, Hal Eckles, G. Homer Burtner, and Arch Wilson. (Courtesy Cupertino Historical Society, Montgomery files.)

In 1912, Fanny Jollyman started the first official Cupertino Branch of the Santa Clara County Library, which consisted of 75 books on four shelves. She began at $5 a month, serving for 31 years until her retirement in 1945. She was the youngest of the Jollymans, born in 1888, and attended Lincoln Elementary School, Santa Clara High School, and Stanford University as well as Union Church. (Courtesy Cupertino Historical Society.)

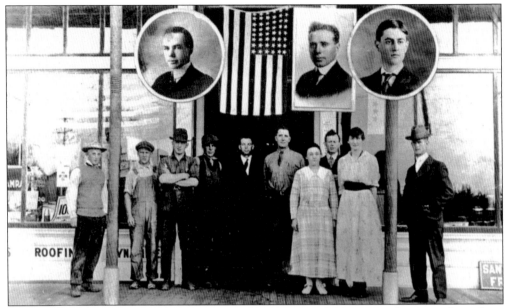

The interior of the Cupertino Store is pictured here during election time. Posing in front, from left to right, are Gilbert Gilsworth, Arthur Jenkins, John Lane, Adolph Nansen, Billy Calvert, Homer Buckner, Claude Parrish, Fanny Jollyman, Honore McCarthy, and Arch Wilson. (Courtesy Cupertino Historical Society.)

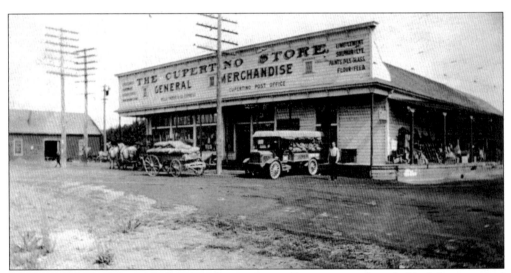

In 1902, Alex Montgomery offered to finance James Dixon to purchase half of the store and set up his nephew, Arch Wilson, as his partner. The store became Cupertino Store, Dixon and Wilson Proprietors, General Merchandise. When Dixon suddenly died in 1904, Arch Wilson became the major store owner with a small share going to employee William B. Calvert and one-eighth to Mrs. Mamie Dixon, who had two growing boys to support. (Courtesy Cupertino Historical Society.)

As a teen, James Dixon's youngest son, Harold, began delivering groceries and local news for the Cupertino Store, later becoming responsible for sales, ordering, and stocking of supplies. Arch Wilson did office work and became involved in public life. Dixon became the store's manager. A born salesman, Harold introduced the first Frigidaire and the first Wedgewood gas stove, and he was the John Deere implement dealer. He guaranteed everything he sold and prepared himself to do repairs. (Courtesy Cupertino Historical Society, Dixon files.)

Annie McNary, a teacher at Moreland School, is pictured below left; William Britton Calvert, who was always called Billy, is pictured below right. They married in 1908. He drove a horse-drawn cart to Lincoln Elementary School and Cupertino Union School and was a partner in the Cupertino Store for 20 years, distributing mail and handling Wells Fargo items. The couple's Victorian home on the northeast corner of Homestead Road and Wright Avenue was a showplace for 30 years. (Courtesy Cupertino Historical Society, Calvert files.)

Billy Calvert lived in Cupertino for 103 years. He belonged to the Cupertino Odd Fellows and Philotesian Rebekah Lodges for 83 years and the Cupertino Masonic Lodge for 56 years. He was treasurer for Union Church of Cupertino for 57 years and worked with the Cupertino Historical Society, the North-West YMCA, the Boy Scouts, and the Cupertino Union School District Board. Five hundred people turned out for his 100th birthday party. He died in 1982 at the age of 103. (Courtesy Cupertino Historical Society.)

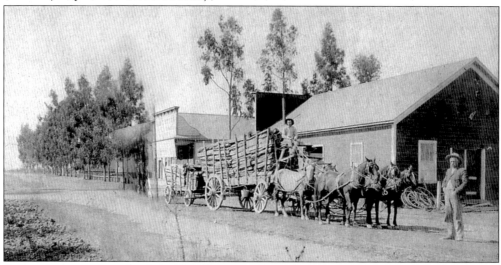

Across the street from the Cupertino Store on the northeast corner of the crossroads was the home and blacksmith shop of William Baer. The Horticulture-Viniculture Association building was also at the corner on land donated by Montgomery. It was used by the Independent Order of Odd Fellows (IOOF) for meetings, and the Union Church was next to that. All three buildings were built by E. J. Parrish, Cupertino's first builder. (Courtesy Cupertino Historical Society.)

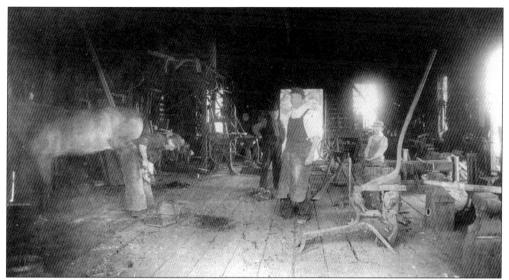

William Baer came to Westside in 1888 to set up a very busy blacksmith shop on the northwest corner of Saratoga-Sunnyvale Road and Stevens Creek Road. He went back to Pennsylvania to claim his bride, Lydia Giesey. Enoch Parrish built their family home next door, where five children were born: Charlie, William Webster, George Albert, Lyla Maria, and Beulah. (Courtesy Cupertino Historical Society.)

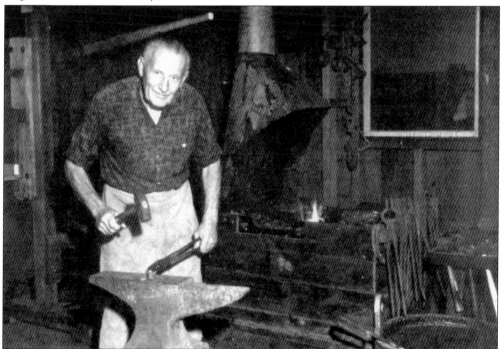

Blacksmith William Baer is seen here in 1920. Charlie was not interested in blacksmithing like his dad, but he made a replica of the old blacksmith shop after William died. It is in McClellan Park. The replica contains typical blacksmithing tools, including everything to repair wagon wheels to tin benders for making stove pipes, and the first wagon his father built for Ethyle's father in 1900. (Courtesy Cupertino Historical Society.)

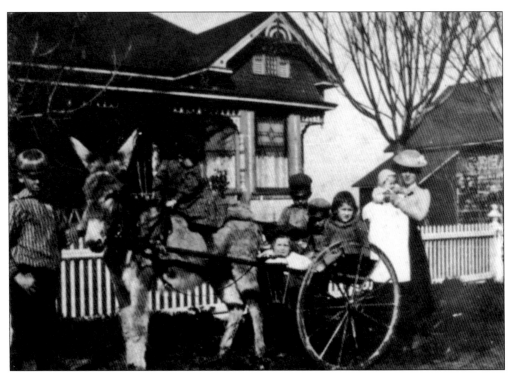

These children are going to school in the Baer Donkey Cart in 1902. Pictured, from left to right, are Carl Parrish, Webster Baer (on donkey), Charlie Baer, Bert Baer, Cyla Baer, Mabel Noonan (in bottom of cart), and Lydia Baer (holding Beulah). (Courtesy Cupertino Historical Society.)

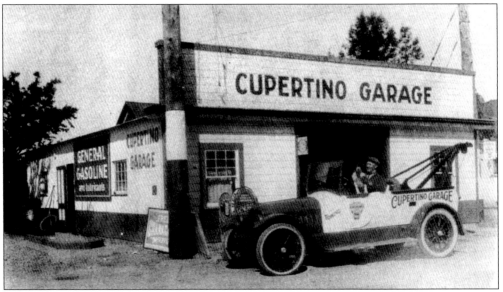

Charlie Baer was born in Cupertino in 1894. He attended Collins School, located near the northeast corner of Homestead and Saratoga-Sunnyvale Roads, with his sisters and brothers, and then San Jose High School. In 1915, Charlie built a small garage and Cupertino's first service station on the site of his father's blacksmith shop. He worked there for 49 years. (Courtesy Cupertino Historical Society.)

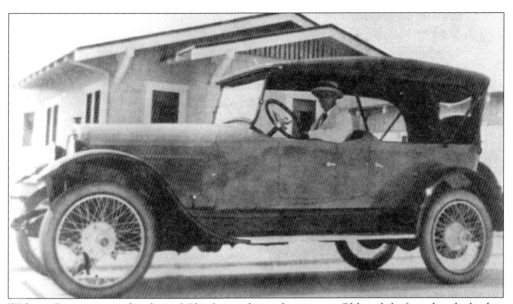

Webster Baer, younger brother of Charlie, is shown here in an Oldsmobile from his dealership in Palo Alto. Charlie, the eldest son, spent his entire life in Cupertino. (Courtesy Cupertino Historical Society.)

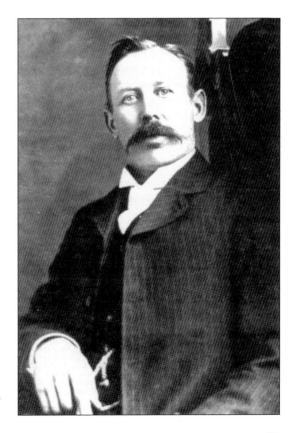

Born in Kentucky in 1858, Enoch J. Parrish came to California in 1879. In 1882, he learned carpentry in Redwood City. In 1883, he purchased 20 acres on the north side of Stevens Creek Road, opposite De Anza College today, constructing a 10-by-12-foot one-room building, drilling a well, and building a tank, tank house, and windmill. He built most of the structures in early Cupertino. (Courtesy Cupertino Historical Society.)

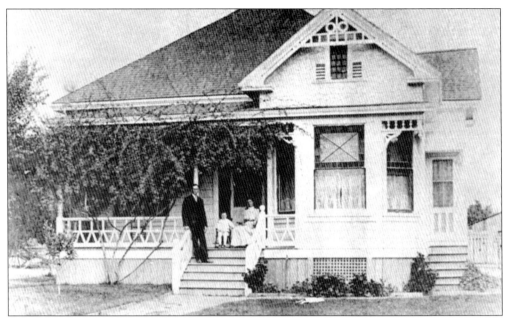

By 1895, Parrish completed a fine Victorian residence on the land. The house had running water because he had a water tank on top of a tank house. He planted grapevines and prune trees, which were not irrigated until he installed a cement reservoir with a capacity of 30,000 gallons, half below and half above ground, which the boys and girls of the neighborhood used for a swimming pool. (Courtesy Cupertino Historical Society.)

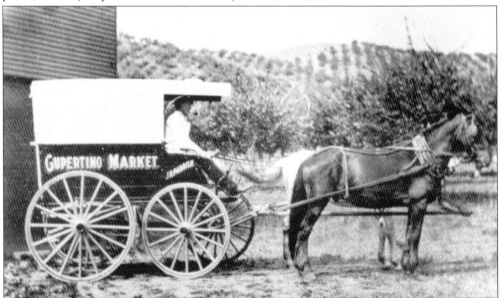

Enoch Parrish also opened a retail meat market in the basement of his Victorian home, moving it later to a house he had built near Cupertino Cross Roads, where Stevens Creek Road and Sunnyvale-Saratoga Road intersect. He covered the Cupertino territory driving a two-horse, camper-type covered wagon that held his cutting block, hanging scales, and all cuts of meats and sausages. He was generous with his hot dogs, to the delight of local farm boys and girls. (Courtesy Cupertino Historical Society.)

The Parrish meat truck was once called upon as a tow truck to rescue Charles A. Baldwin and his chauffeur-driven yellow Renault when it broke down. Baldwin, the owner of Le Petit Trianon and the Millefleurs Winery on his Beaulieu Estate, where De Anza College is today, was mortified. The noisy yellow Renault could be heard at great distances, enough to attract small boys like Ralph Rambo (on the fence in this illustration) and allow horses to be brought to safety. (Illustration by Ralph Rambo from *Remember When . . . A Boy's-Eye View of an Old Valley.*)

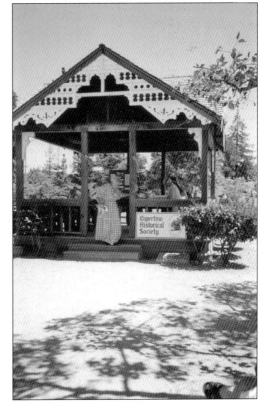

After the city bought the land for Memorial Park, the 12-room Parrish house served as a drop-in center for seniors where the Senior Center is today. Historians fought to save the house for a historical museum, but it was frequently vandalized and finally burned in a suspicious fire in 1975. Parts of the Victorian gingerbread were saved and placed on a gazebo in Memorial Park in 1977. All of the Parrish buildings that were erected in Cupertino are gone. (Courtesy Cupertino Historical Society.)

John Snyder came to California in 1849 with the Tipton Company wagon train from Pennsylvania. He mined for gold in Trinity County, coming to Santa Clara County in 1854. He bought 1,163 acres from Spanish land grantees in the Permanente Creek area, where he grew grain on 500 acres and had 25 acres in fruit and 16 acres in vines. (Illustration from *Pen Pictures from the Garden of the World or Santa Clara County, 1888.*)

In 1883, Snyder built a two-story Craftsman house for his daughter and her husband, Dr. W. H. Hammond, which still stands on Permanente Road. Snyder's children rode their horses to San Antonio School. His land was later sold to the San Francisco Catholic Diocese, which sold some to Kaiser Permanente, Maryknoll, Gates of Heaven Cemetery, Interstate 280, and Mid-Peninsula Parks. (Courtesy Mary Lou Lyon.)

# Four
# VINEYARDS AND WINERIES
# OF THE 19TH CENTURY

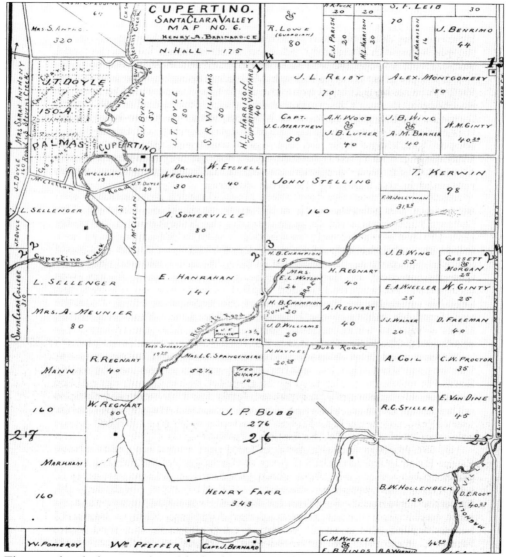

This map details the ownership of the land in 1885. Visible are the relationships of the properties mentioned here, as well as the creeks. Note John T. Doyle's Las Palmas and Cupertino wineries on the left. (Courtesy Charles L. Sullivan, *Like Modern Edens: Winegrowing in Santa Clara Valley and Santa Cruz Mountains, 1798–1981.*)

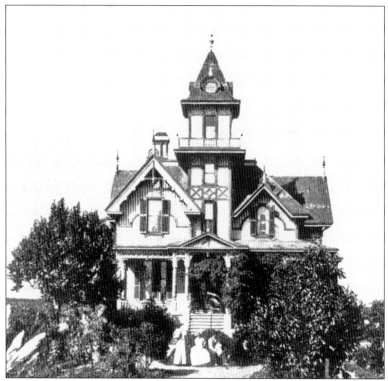

Louis Portal was the first vineyardist in the Cupertino area. He planted burgundy grapes on his land. In 1893, he returned to France with his beautiful, blonde second cousin, abandoning his wife, Mathilde, and seven children. She continued with the vineyard and the winery until the late 1890s. The beautiful Victorian mansion on Portal Avenue was torn down in 1959. (Courtesy Cupertino Historical Society.)

Capt. Joseph C. Merithew, a Maine sea captain, bought Norman Porter's 1871 vineyard in 1879, naming it Prospect Vineyard for his birthplace, Prospect, Maine. Merithew's third child, Sarah Josephine, married Capt. Norman Dunbar at her Uncle Porter's residence in 1886. Captain Merithew's last voyage out of San Francisco was in 1887, when he retired to become a leader in viticulture in Cupertino, as did several other sea captains. (Courtesy Cupertino Historical Society.)

Parrish remodeled the Porter home in 1887 for Captain Merithew, whose 36,000 vines filled 40 acres bordered by Stevens Creek, Bubb Road, and McClellan Road. Annual production was 6,000 gallons of wine, particularly Sylvaner, White Riesling, and Zinfandel, but at the 1893 Columbian Exposition in Chicago, Merithew won awards for sherry, port, and brandy. The sherry was baked in glass-covered compartments in the ground to get the nutty, authentic flavor. (Courtesy Cupertino Historical Society.)

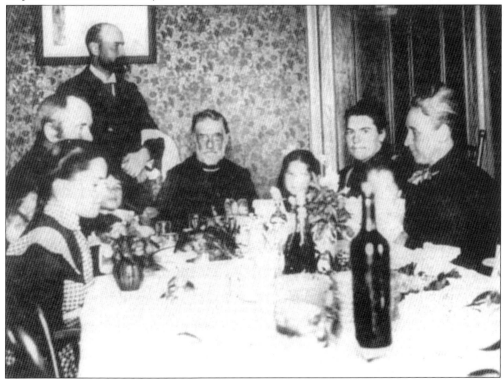

Capt. Joseph C. Merithew and Mrs. Sarah H. Black Merithew hosted Dr. Edwin H. Durgin and Mrs. Anna Durgin for Thanksgiving in 1898. Note the wine bottles on the table, which are surely Captain Merithew's own vintage. (Courtesy Cupertino Historical Society.)

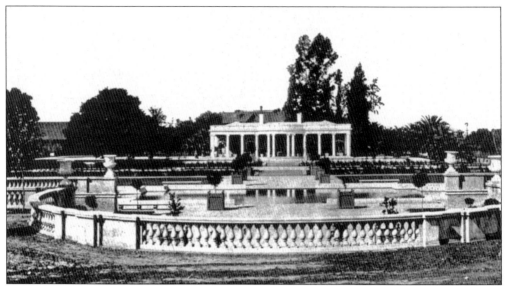

In 1892, Rear Adm. Charles S. Baldwin bought 137 acres on Stephens Creek Road where De Anza College campus is today, naming it Beaulieu (good earth). One of Cupertino's first millionaires and another sea captain, Baldwin was also a polo player, and he and his friends practiced polo on the field opposite his house. Baldwin did not dazzle the countryside until after he married San Francisco heiress Ella Hobart. (Courtesy Cupertino Historical Society.)

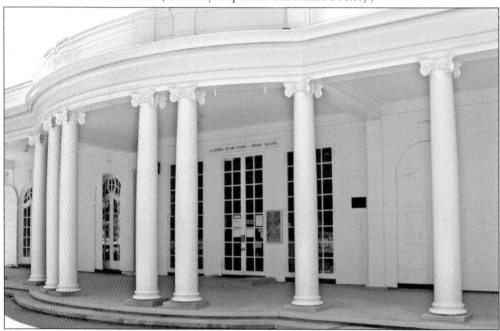

Rear Adm. Charles Baldwin had a replica Le Petit Trianon built for his summer house (his main home was in San Francisco), plus stables, servants' quarters, guest houses, a swimming pool, and a winery. The Trianon was moved in 1974 and restored in 1979. It is on the National Register of Historic Places and houses the California History Center and the Louis Stocklmeir Library, which still has floor-to-ceiling shelves of books and an oval skylight. The Louis XVI dining room and salon was furnished in gold. (Courtesy Cupertino Historical Society.)

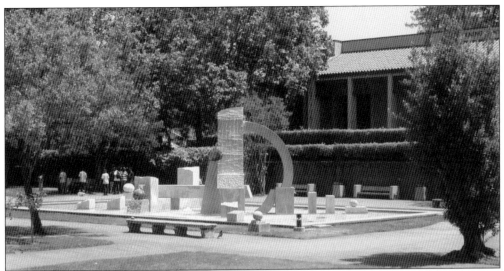

The 10 acres around the house were also a reproduction of the French original with neoclassic Ionic columns and formal sunken gardens, pathways edged with balustrades, and a reflection pool with a fountain that he called Millefleurs (thousand flowers). He built the first swimming pool in the area and the first polo grounds. Today the reflection pool sports a "modern" sculpture, not the original. (Courtesy Tim Peddy.)

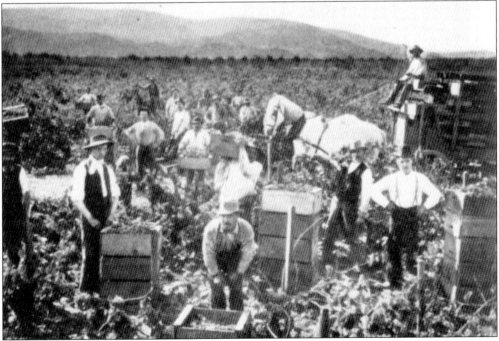

Beaulieu was still a working vineyard until phylloxera killed the grapes around 1900. Baldwin could have replanted but instead took his wife, Ella Hobart Baldwin, who was suffering from tuberculosis, to Colorado Springs, selling the property to Francis and Harriet Pullman Carolan, the heiress to the Pullman railroad car fortune. The admiral died, and his widow was briefly remarried to a younger Balkan prince in 1953. She died in San Francisco. (Courtesy Charles L. Sullivan, *Like Modern Edens: Winegrowing in Santa Clara Valley and Santa Cruz Mountains, 1798–1981.*)

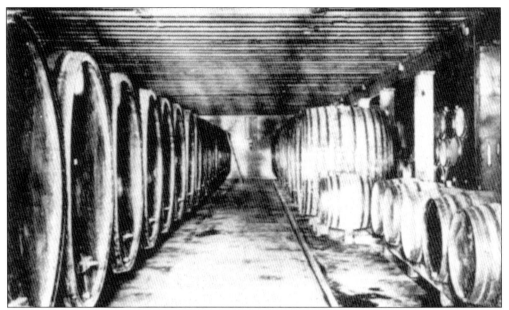

In this image, wine is being aged in oak casks in the winery. The winery was built with an underground cellar to ensure even temperature and humidity for the aging of the wine. Great care was taken in the aging, bottling, and exporting of the Millefleurs label. Admiral Baldwin exported to the East Coast, London, and Central America, where it competed favorably with French wine, winning some ribbons at European and American expositions. (Courtesy Charles L. Sullivan, *Like Modern Edens: Winegrowing in Santa Clara Valley and Santa Cruz Mountains, 1798–1981.*)

The final owner of Beaulieu, including the stone winery pictured here, was E. F. Euphrat, president of the Pacific Canning Company, who developed the deepest well in the county to irrigate his orchards. His profit was $10,000 to $15,000 annually. He sold to the Foothill College District in 1963 with a specific request to save the Trianon and the massive stone winery, which has been done. The winery has been used as the college bookstore. (Courtesy Charles L. Sullivan, *Like Modern Edens: Winegrowing in Santa Clara Valley and Santa Cruz Mountains, 1798–1981.*)

Samuel R. Williams and his sons Joseph (J. D.) and Albert came to the area in 1870 and lived in a cabin while they cleared 100 acres of level farming land and planted vines. Vintner Nathan Hall gave Williams 50 acres if he would clear his 100 acres and plant grapes. Jane Hume Williams stayed in San Jose with Melissa and Augustus until there was a house for them. The men did other seasonal work to earn money until they got their own land, including plowing, cutting hay, jumping the hay press into bales, and digging wells. (Courtesy Cupertino Historical Society, Williams files.)

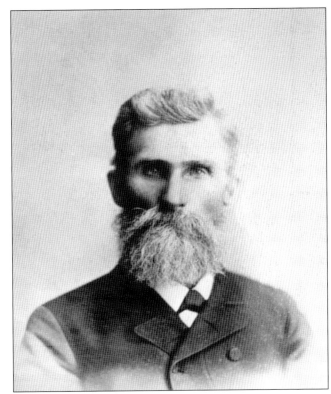

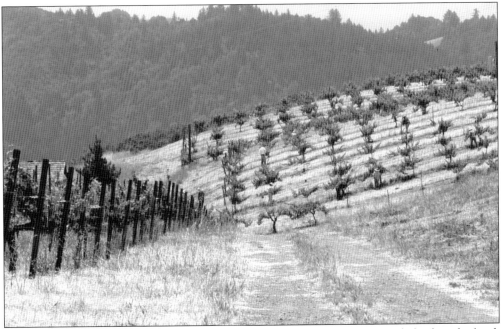

Samuel Williams hired some Chinese workers from San Jose's Chinatown to help clear the land. Once, while burning piles of brush, they contracted a terrible rash and had to go back to San Jose to be treated for poison oak. It was nearly fatal, but after many weeks of agony, they returned with a lesson well learned. (Courtesy Tim Peddy.)

In 1880, J. D. (Joseph) Williams bought a second winery, Captain Merithew's, and moved it to the corner of Stelling and Stevens Creek Roads. In 1895, he made 160,000 to 200,000 gallons of wine (one ton of grapes makes 150 gallons of wine). Some was made on shares, J. D. keeping 50 gallons out of each 150 gallons made for others. In 1895, it sold for 12.5¢ per gallon. (Courtesy Cupertino Historical Society, Williams files.)

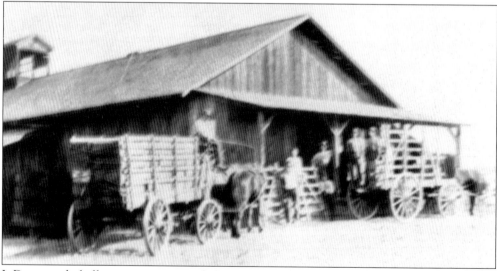

J. D. secured phylloxera-resistant stock from France and replanted his grapes on 20 acres at Sunnyvale-Saratoga Road and Homestead Road. He planted petit sirah, cabernet, green Hungarian, and golden chasselas to produce both red and white wine, then added a distillery to make brandies flavored by the fruits of the valley. Joe planted apricots and prunes, and the winery became a prune-packing house after phylloxera killed the grapes. (Courtesy Cupertino Historical Society, Williams files.)

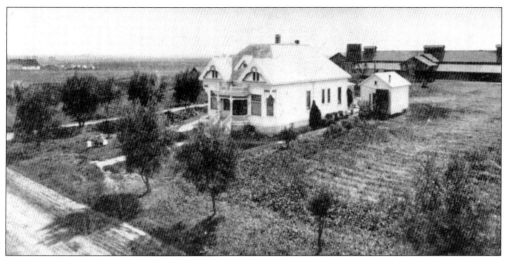

J. D. Williams's home was on the south side of Stevens Creek and Stelling Roads. By 1895, he was producing 160,000 to 200,000 gallons of wine a year. The house sat on top of a 14-foot aging cellar. He gave the railroad frontage in exchange for a spur track for shipping. Williams made wine from other people's grapes on shares, some from as far away as Sacramento and San Joaquin Valleys. (Courtesy Cupertino Historical Society, Williams files.)

Augustus Williams ("Gus"), the family clown, had a rich baritone voice that could be heard every evening as he sat on the Rose Cottage porch, accompanying himself on a Martin guitar with his wife, Adda, a contralto, and their daughter Mabel singing lead. Sometimes brother Al would make it a quartet. (Courtesy Cupertino Historical Society, Williams files.)

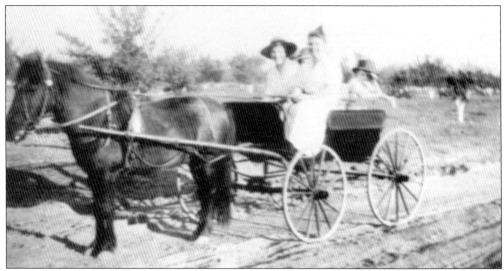

J. D. Williams's Shetland pony, Jack, is pictured with a pony cart and with Helen, Claire, and Mabel Williams holding the reins. Mabel attended the same school as her father, Gus, San Antonio, although her attendance was better. She graduated from Notre Dame High School in San Jose and San Jose Normal School as an elementary teacher. In 1919, she was hired by the new Cupertino Union School District, where she remained for 18 years. (Courtesy Cupertino Historical Society, Williams files.)

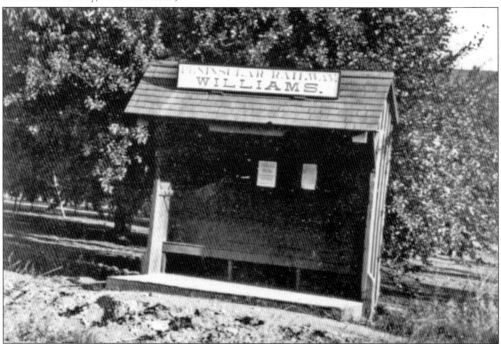

J. D. Williams gave property to the new rail line between San Jose and Palo Alto in exchange for a four-car spur and a flag stop at Williams Station. He brought in various fruits to use in his fruit brandy, which used a vacuum system. Prohibition forced him out of business in 1918. The machinery was sold to salvage dealers, and the tanks were sold to farmers for water storage. (Courtesy Cupertino Historical Society, Williams files.)

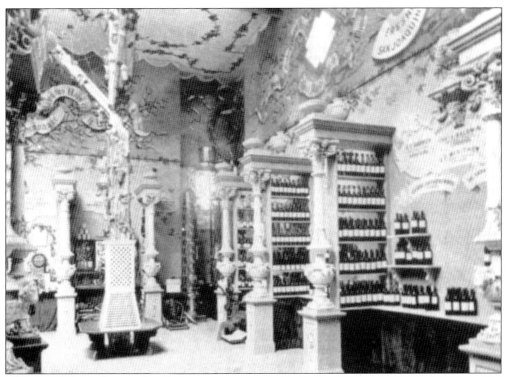

The Viticulture Palace at the 1915 Panama-Pacific International Exposition in San Francisco prominently displayed wines from this area, including those of Adm. Charles Baldwin and Capt. Joseph Merithew. (Courtesy Charles L. Sullivan, *Like Modern Edens: Winegrowing in Santa Clara Valley and Santa Cruz Mountains, 1798–1981.*)

"Aunt Em" Meyerholz lived at her parents' house, the Christian Meyerholz, at Homestead and Wright Avenue until 1948. She and her horse, Babe, delivered mail in Cupertino. After retirement, Babe still stopped at every mailbox. Emma was one of the first women to drive a car, hollering "Whoa!" every time she put on the brakes. She also played whist and poker and sometimes smoked cigarettes. She "took in" children to raise. (Courtesy Cupertino Historical Society.)

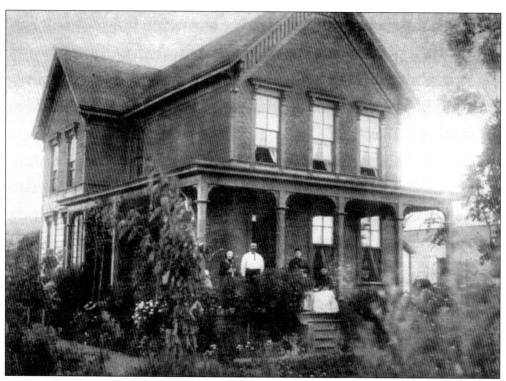

In 1882, John T. Doyle, a San Francisco attorney for the Archdiocese of San Francisco under His Grace Archbishop Patrick W. Riordan, purchased 320 acres near McClellan Road and Foothill Boulevard. Doyle's avocations included history, horticulture, and viticulture. His first winery was called the Cupertino Winery, after the little creek that today is called Stevens Creek. He planted the very best varietals and experimented with premium varieties. (Courtesy Cupertino Historical Society.)

Doyle's 1886, four-story masterpiece, Las Palmas Winery, was modern, automated, and marked by the double row of Washington palms off Foothill Boulevard. He had the best wines in the state at that time, winning a medal at the Columbian Exposition of 1893 in Chicago for his 1890 cabernet franc and, at Bordeaux, a silver medal in 1895, the only California winner. The 1906 earthquake shattered his wineries. (Courtesy Tim Peddy.)

# Five
# MONTEBELLO RIDGE AND UP THE CANYON

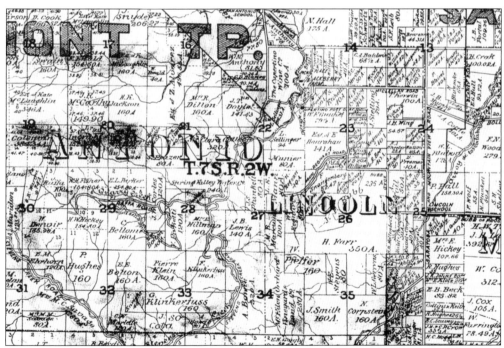

This 1890 map shows the Regnart and Picchetti properties. William Regnart Jr. grew wheat in the flatland before buying 120 acres of untamed land up Regnart Canyon to raise grapes, with a right-of-way through Theodore Scharf's property. It was filled with trees, shrubs, wild animals, snakes, and birds. Wildflowers grew in profusion. Water came from a hillside spring and a well in the creek. (Courtesy Cupertino Historical Society.)

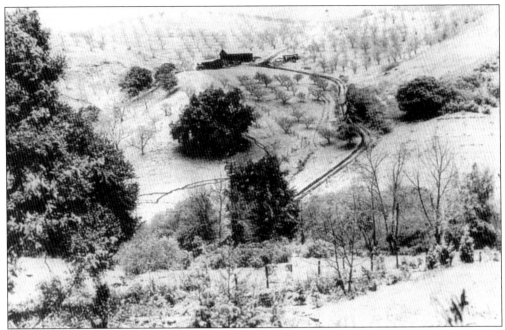

The Regnart orchard is pictured here in a rare snow in 1962. At this time, the Regnart family included Maggie Croal Regnart, Jessica (age 11), and Herbert (age 9). Regnart built a two-story home with a fireplace in the living room and a wood stove in the kitchen. He had a small winery and sold wine to England, where he and his brothers were born. His six children—Margaret, Hazel, Eva, Alice, Herbert Jr., and Donald—grew up in the canyon. (Courtesy Cupertino Historical Society.)

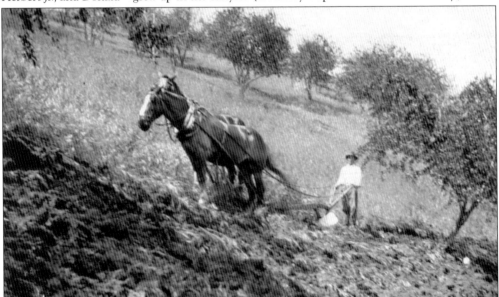

Phylloxera killed Regnart's vines, so he replanted with almonds, prunes, apricots, and peaches. The hillsides were too steep for tractors, so the work was done by hand or with horses and plows. The principal harvesters were the children, and sometimes there was migrant help. Sometimes the buckets of prunes would tip over on the steep hillside, spilling the contents, so they soon learned to level a spot for their buckets. (Courtesy Cupertino Historical Society.)

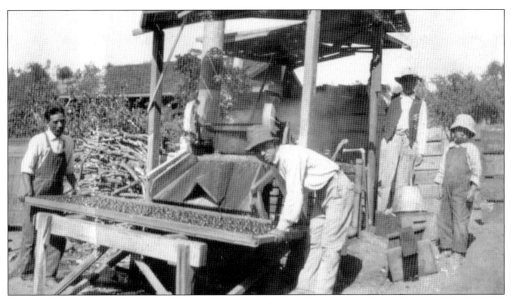

Harry Iwagaki is pictured here sulfuring prunes. Whole families picked the prunes off the ground to be certain they were dead ripe with sugars. Sometimes mothers would sew pads on the knees of their families' pants. The prunes were dipped into a boiling lye bath to crack the skins, laid out on trays in the sun to dry, then taken to Sunsweet, Sun Dried, or Mariani to prepare for market. (Courtesy Harry Iwagaki files.)

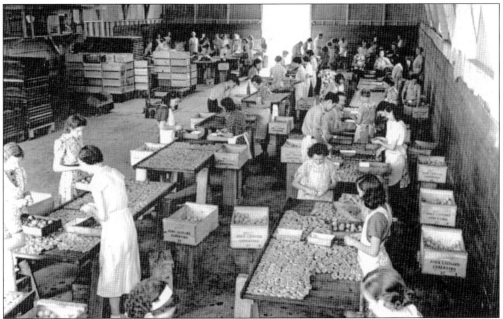

Before the advent of more modern production methods, the entire family "cut 'cots" (see page 70), placing them on wooden trays, which were then stacked, put in the sulfur house overnight, and then laid out in the sun for four or five days. When dried, the fruit was taken to a packing house and labeled Sun Sweet or Sun Dried. If the rains came while they were drying, the family had to rescue them or the entire year's income could be lost. (Courtesy Cupertino Historical Society, Leonard files.)

From 1886 to 1909, the Regnart brothers' children, including William's six, Herbert's four, and Robert's seven, attended Lincoln School, walking three miles each way along Regnart Creek, up a hill and down the railroad track, to Prospect Road. In 1921, the four small schools were consolidated into Cupertino Union School. The children walked down Regnart Canyon, leaving their muddy shoes in the mailbox and changing shoes, catching the bus at 7:30 a.m. and returning at 4:45 p.m. (Courtesy Tim Pedddy.)

## The Richard Heney Vineyard and Winery

In 1884, Richard Heney Jr., a San Francisco furniture dealer, came to Santa Clara Valley to regain his health in a warmer climate. He purchased 100 acres of chaparral in the area. He cleared the land and planted 55 acres in Isabella, Tokay, petit sirah, and zinfandel grapes. Chateau Ricardo winery had a great reputation for its estate-bottled clarets, receiving some medals for his wine at the Paris Exposition. (Courtesy Cupertino Historical Society, Emig files.)

Chateau Ricardo was made of concrete and brick against the hill, with three stories. The grapes went in at the top, down to tanks at a lower level, and finally to the cellar for aging. Initially he spent $30,000 for the building, which is still there. (Courtesy Cupertino Historical Society.)

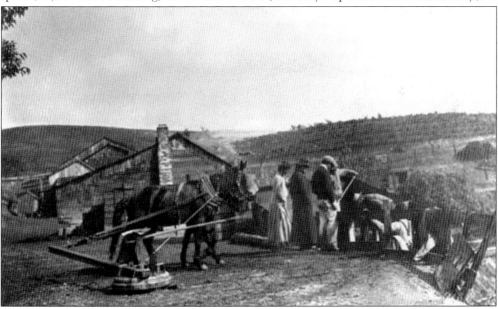

In 1886, Dr. Osea Perrone purchased 180 acres on the crest of Montebello Ridge for 1,550 gold coins. He practiced medicine in San Francisco, but viticulture was his hobby. He built a huge stone cellar and commissioned an Italian architect to build a summer house over the cellar using redwood, madrone, and oak. Wagons full of building supplies took half a day to come up the eight-mile road through the chaparral to his "beautiful mountain." (Courtesy Cupertino Historical Society.)

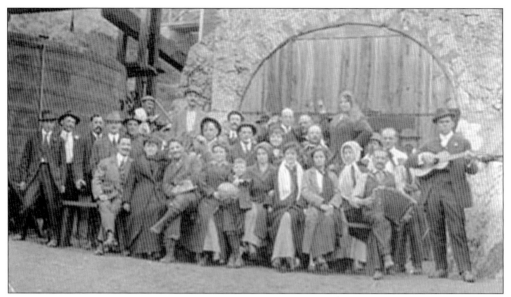

According to the Ridge Winery's Web site, it was taken over in the 1950s by four electrical engineers from Stanford Research Institute as a hobby. They purchased the "unloved vines on the ridge." In 1971, Paul Draper, also from Stanford, who had crafted his expertise in Chile, France, and Italy, took over as wine-master. Their specialties are cabernet sauvignon, petit verdot, merlot, and chardonnay. They are open to the public only on weekends. (Courtesy Ridge Winery Web site.)

In 1888, Pierre Klein purchased 160 acres on Montebello Ridge for $3,800 in gold coin. His Mira Valle Wines were internationally acclaimed. At the Paris Exposition of 1900, he won two gold medals, one for clarets and the other for his Grand Vin, described as the "Chateau Lafitte of America." He sold 160 acres with crops and buildings to John M. Williams in 1913 for $10, for unexplained reasons. (Courtesy Tim Peddy.)

In 1872, Vincenzo Picchetti came to work for the fathers at Villa Maria, a retreat owned by the Jesuits in Santa Clara. They encouraged him to buy land on the Montebello Ridge, which he and his brother, Secondo, did, purchasing 160 acres for $1,500. The first house was built in 1870. Secondo and his wife, Theresa, cleared the land, planted vines, and harvested timber for firewood down in the valley. (Courtesy Cupertino Historical Society.)

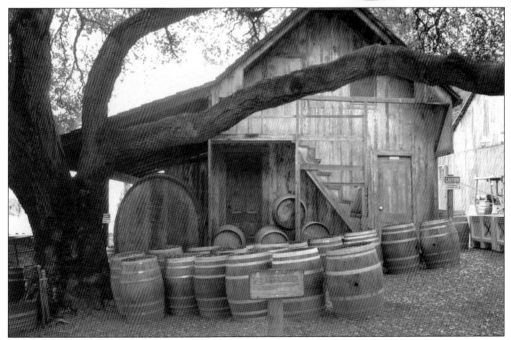

Secondo's wife, Theresa, had an encounter with a bear, so they moved to San Jose. Vincenzo in 1884 bought his brother's half interest and moved onto the ranch with his wife, Theresa. (Both wives were named Theresa.) They had chickens, geese, hogs, ducks, pheasants, peacocks, a raccoon or a wild badger, and an aviary of canaries. Hired hands were boarded on the second floor of the homestead house until the big house was built in 1885. (Courtesy Tim Peddy.)

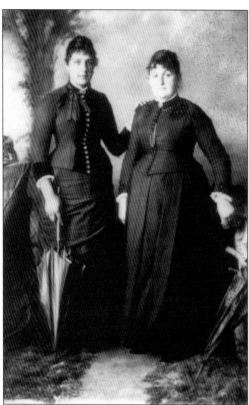

Louisa Cicoletti arrived from Italy in 1888 to help her sister Theresa (Vincenzo's wife) raise her growing family. She also supervised the winery and wine making. She is pictured here with Theresa Picchetti, who is holding the umbrella. (Courtesy Cupertino Historical Society, Picchetti files.)

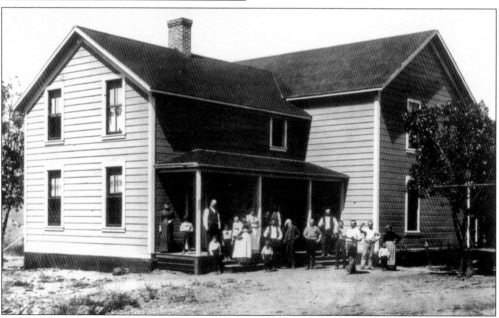

The entire Picchetti family always gathered at the ranch house for Sunday dinner, seen here in 1885. Vincenzo and Theresa Picchetti had 6 sons (raising 4), 7 grandchildren, 9 great-grandchildren, and 18 great-great-grandchildren. A fifth generation was started in 1991. (Courtesy Cupertino Historical Society, Picchetti files.)

Vincenzo's son Antone started school in 1890–1891, but Lincoln School was so far that the neighbors on the mountain opened their own school, closer to home, in 1892; it is still operating. The Picchettis supplied a room for the teacher and $250. Montebello School had a Picchetti on the school board from 1892 to 1975. All four boys—Antone, John, Attilio, and Hector—attended and went on to business college in San Jose. (Courtesy Cupertino Historical Society, Picchetti files.)

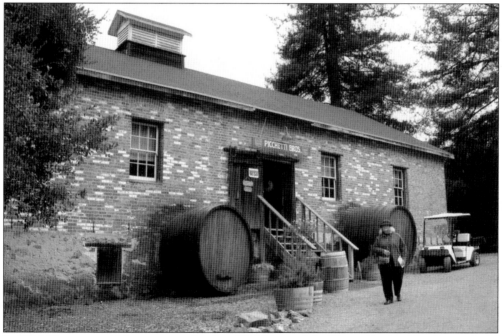

In 1896, Teresa urged Vincenzo to take their $8,000 out of the Union Bank of San Jose to build a winery. The bank failed the next week. They built a two-story red brick building into the side of a hill. They bottled and sold their red and white wines under the Montebello label after aging them at least three years. Their last year was 1963, and they closed the winery in 1972. (Courtesy Tim Peddy.)

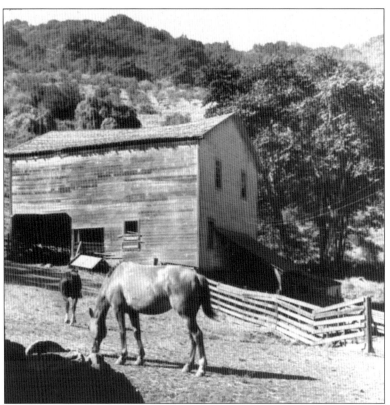

The old Picchetti barn has been removed. The ranch and winery were sold to Mid-Peninsula Open Space District in 1977. Today the winery and house are leased out, and wine is again being produced under the Picchetti label. The winery and wine cellars have been brought up to code, but they are still in the original brick building. The historical society holds some events there. (Courtesy Mary Lou Lyon.)

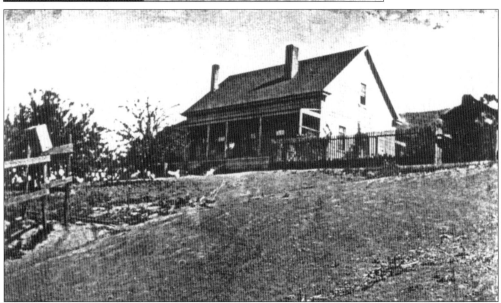

Fremont and Cora Older purchased their 160 acres of orchard, vineyard, and woods from William Pfeffer in 1912. Pfeffer, a German immigrant, had settled in the area in 1868. His specialty grapes earned him a bronze medal at the 1904 St. Louis World's Fair for his cabernet. Between 1895 and 1905, he had replaced the phylloxera-blighted vines with prunes, apricots, and olive orchards. (Courtesy Cupertino Historical Society, Pfeffer files.)

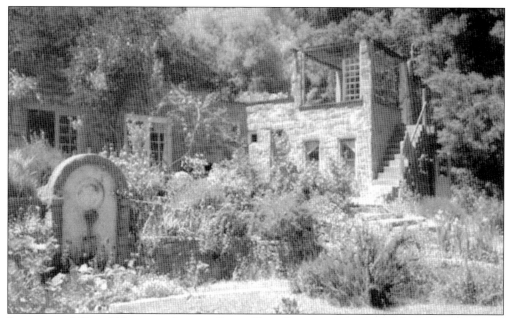

Fremont and Cora Older came down to Santa Clara County every year for the Blossom Festival in Saratoga. The famous San Francisco editor crusaded against political graft. They built a house of a uniquely livable modern California design, not Victorian, in 1913 above Cupertino and named it Woodhills. The house was designed by Wolfe and Wolfe. (Courtesy Cupertino Historical Society files, Older files.)

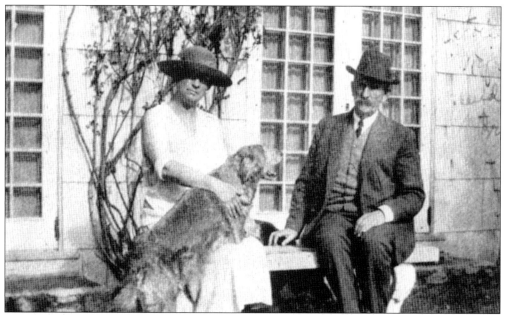

Fremont and Cora Older are pictured here. Fremont rose at 5:00 a.m., breakfasted at 6:00, and at 6:30 drove his White Steamer down the twisting, narrow road to Fremont Station to catch the 6:37 a.m. train at the corner of Stelling and Prospect Roads. Two and a half hours later, he was in San Francisco and working. At 4:00 p.m., he returned to his hillside home. (Courtesy Cupertino Historical Society, Older files.)

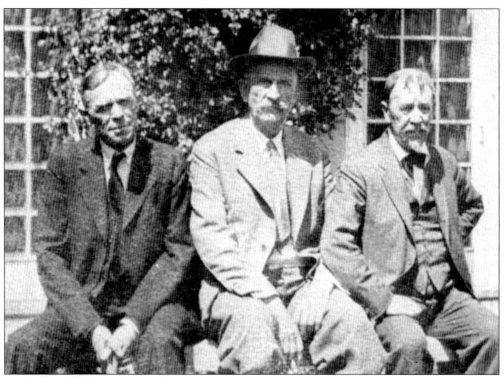

The Olders had 200 acres of fruit trees, which were cared for by loyal ex-convicts to whom he gave work, including Jack Black, pictured here (on the left) with Fremont and Lincoln Steffens. Other famous guests included Emma Goldman, Carl Sandburg, Painless Parker, Mrs. Robert Louis Stevenson, W. R. Hearst, Mrs. Rothchild, Clarence Darrow, David Starr Jordan, Gertrude Atherton, John Dewey, Rose Wilder Lane, James Rolph, S. S. McClure, Hiram Johnson, Allen Cranston, Sen. James Phelan, Rudolph Spreckles, and many others. (Courtesy Cupertino Historical Society, Older files.)

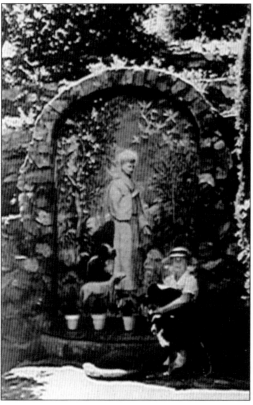

Cora wanted a rock fountain and a grotto. An Italian stonemason was recommended to her who had worked on the Italian pavilion in the 1915 Panama-Pacific Exposition in San Francisco. He spoke no English, but she spoke a little Italian. Frederico Quinterno came and made the fountain, stone walls, and other rock work. He also worked on Painless Parker's nearby ranch and Seven Springs Ranch. (Courtesy Cupertino Historical Society, Older files.)

# Six
# ORCHARDISTS IN THE 20TH CENTURY

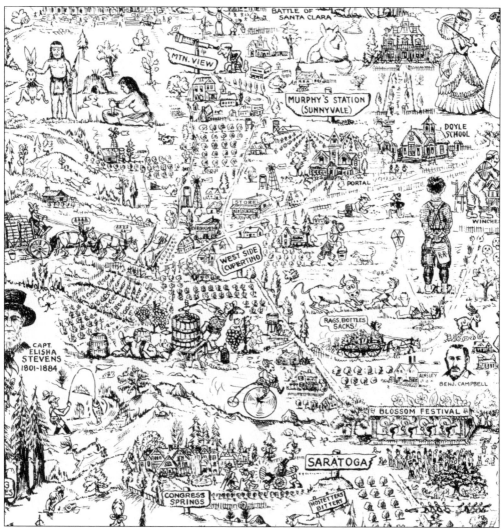

Ralph Rambo's cartoon map of Santa Clara County from *Remember When . . . A Boy's-Eye View of an Old Valley* shows a boy standing with his back to us and "R. R." on his lunch bucket, facing Doyle School. This portion of the map shows Indians above left, Capt. Elisha Stephens on the left, old-fashioned grape presses, rows of grapes and trees, the Saratoga Blossom festival below, and many more landmarks and clever comments that afford a close examination.

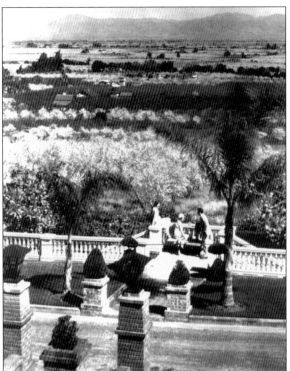

Painless Parker had this view of Cupertino from his house off Prospect Road in the foothills above the blossoms. He was a flamboyant dentist who had his first name legally changed to "Painless" because he was accused of advertising his dentistry, a practice that was frowned upon at the time. At his prime, he employed 244 people, including 79 dentists. He caught the train to San Francisco at Azule Crossing, where the train tracks cross Sunnyvale-Saratoga Road. (Courtesy Cupertino Historical Society.)

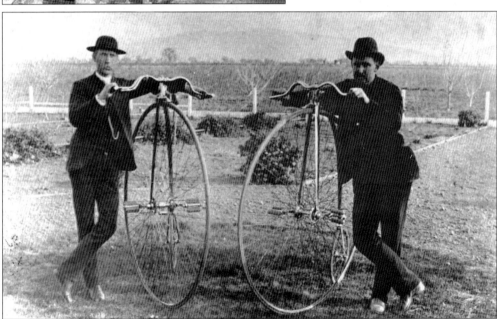

Henry J. Stelling (left) and his brother-in-law are pictured here with high-wheeled bicycles in 1890. H. J. Stelling purchased 70 acres from the Hollenbecks around 1900, clearing the land and planting cherries inter-planted with peaches and another orchard of Comice and Winter Nellie pears, interplanted with walnuts. The Stellings lived in the Hollenbeck house for some years until they could afford to remodel it into a palatial Mediterranean-style house. It became a meeting place for the rich and famous. (Courtesy Cupertino Historical Society.)

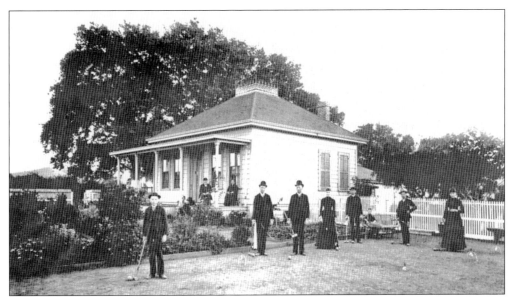

The Stelling house had a three-acre garden with large oak trees surrounding the house. Alice Helwig Stelling kept two flocks of peacocks strutting around and nesting in the oaks to warn the residents if any visitors came on the property. Here the family is enjoying croquet. (Courtesy Cupertino Historical Society, Stelling files.)

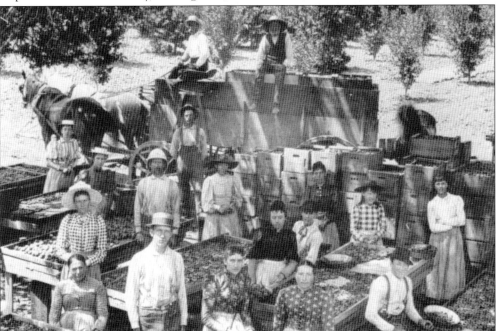

H. G. Stelling bought a quantity of paint from Camp Fremont in Menlo Park after World War I. In 1926, spontaneous combustion set it off, sparking a spectacular fire and explosion that was heard as far away as Los Gatos. It burned down the packinghouse, blacksmith shop, garage, and H. G.'s son Donald's Model A touring car he had just bought, but not the house. H. G. designed a new packinghouse for sorting and packing cherries. (Courtesy Cupertino Historical Society, Stelling files.)

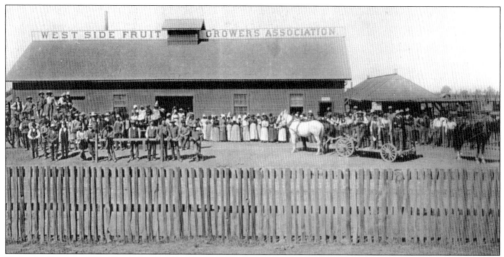

Pictured here is the Westside Fruit Growers Association. The most lucrative markets for the perishable cherries were in Chicago, New York, and Boston, which required refrigeration in the freight cars. H. G. Stelling was instrumental in forming a cooperative, the California Fruit Exchange, for shipping and marketing them. He was one of the first directors of the California Fruit Exchange and one of the first trustees of the Fremont Union High School District. (Courtesy Cupertino Historical Society.)

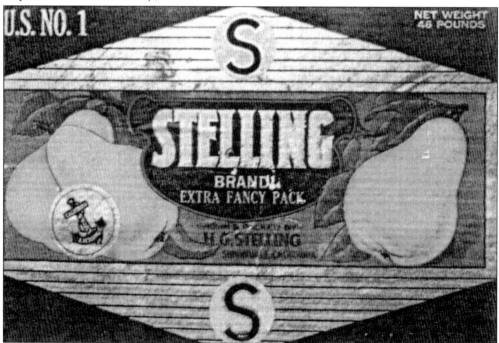

The Stellings had two children, Dorothy and Donald. In 1934, Donald married Miriam Calvert and took over the ranch after his father's death, building a California-style home at the other end of the ranch. Donald was a member of the board of directors of the California Fruit Exchange, president of the Santa Clara County Cherry Growers Association, and chairman of the Santa Clara County Republican Central Committee. The Stelling label for pears is seen here. (Courtesy Cupertino Historical Society.)

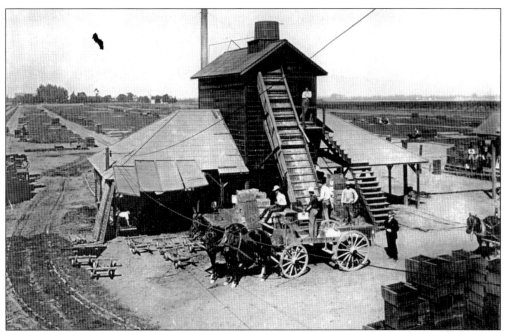

Prunes are being unloaded at the Westside Dryer. Rolla Butcher came west with Gen. Albert Sidney Johnston's expedition to Salt Lake City in 1858; then he went farther west to Butte County, and in 1881, he gave up gold mining for farming an orchard in Santa Clara County. He died in 1882, leaving his widow, Emma; son Rolla II; a daughter, Josephine; and son Arthur, who was then nine years old. (Courtesy Butcher family archives.)

Arthur Butcher made his own tractor, seen here in his orchard. Robert T. Butcher, his youngest son, inherited his mechanical ability. Robert attended Cupertino Union Grammar School and Stanford University, then went into business with his father, managing the local orchards. The home place at Butcher's Corners was his residence with his wife, Audrey Keesling Abbott, and three children, Andy, Margaret, and Barbara. (Courtesy Butcher family archives.)

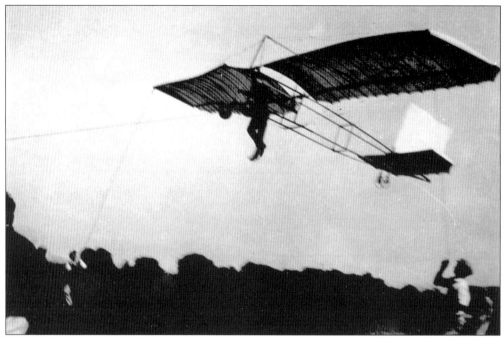

Robert Butcher constructed a glider in the family barn in 1928 from plans in *The Boy Mechanic*. The 30-foot wingspan was covered with his mother's bedsheet made stiff by coating with a flour-and-water paste. He flew it here briefly, in a vacant field in Monta Vista after it was pulled off the ground by seven or eight running boys, including Angelo and Paul Quinterno, Clare Goodrich, and George Fujii. (Courtesy Butcher family archives.)

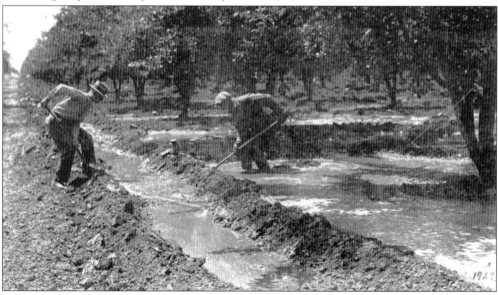

Robert Butcher irrigates his orchard in 1929. His son Andy still farms the remaining orchard at Butcher's Corners after his day job in charge of horticulture at Stanford University. Audrey Butcher remains in their home and is concerned with affairs in Westside, although their property is now considered in Sunnyvale. She shared many old family photographs for this volume. (Courtesy Butcher family archives.)

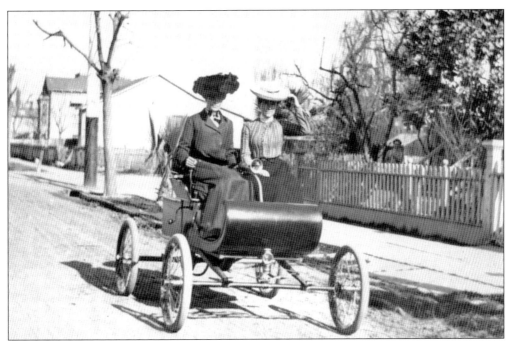

Pictured c. 1904, this is the Butcher family's first Oldsmobile. On the left is the matriarch of the family, Emma (wife of Rolla Butcher), and her daughter Josephine Butcher Hollenbeck is on the right. Emma came from Camdentown, England, on an Latter-day Saint ship, then across the plains with a wagon train to Salt Lake City. She married Rolla in the late 1850s in Butte County, California, and went with him to other gold mining areas in Idaho and Montana before settling in Santa Clara County. (Courtesy Butcher family archives.)

The Butcher family's second Oldsmobile is pictured here, probably about 1907. By running a boardinghouse, Arthur had made enough in the Alaskan gold rush to afford the latest things. Advertising by Olds at the time included this song: "Come away with me Lucille, / In my merry Oldsmobile, / Down the road of life we'll fly, / Automobiling you and I. / To the church we'll swiftly steal, / Then our wedding bells will peal, / You can go as far as you like with me, / In my merry Oldsmobile." (Courtesy Butcher family archives.)

"Goes so fast, you need a windshield," reads the caption for this image in the Butcher family scrapbook. The huge oak in the background is still in the family orchard, but the packing shed is gone. In the front seat are Grace Butcher and one of her sons. In the back with a hat on is Robert and the other son. There are also two more ladies (wearing hats) probably Emma and Josephine. (Courtesy Butcher family archives.)

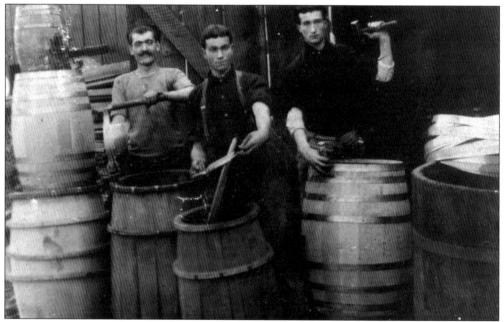

Henriette Andresen and Louis Paviso Sr. were married in 1899 in Healdsburg, California, where Paviso was a cooper for the wineries. Working with oak aggravated Paviso's asthma, so the couple moved to Cupertino in 1905. The family was renting in Joseph Wolfe's house during the 1906 earthquake, which damaged the chimney and tank house. Louis Paviso Sr. died at 49 in 1916, leaving his widow with five children to raise on her own. (Courtesy Cupertino Historical Society, Paviso files.)

Catherine Paviso remembered Christmas when her Danish mother, Henriette Andresen Paviso (pictured here), started baking cookies and fruit cake in November. The family spent their evenings stringing popcorn and making links of red and green paper for the candlelit tree. The Christmas dinner was auspicious, with her father presiding over the golden turkey. Then the plum pudding was carried in, all aflame. On that day, the horse, cow, pigs, and chickens always got extra, too. (Courtesy Cupertino Historical Society, Paviso files.)

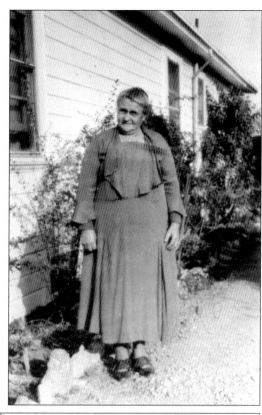

Louis Paviso Sr. made friends with Jason Thomas, an African American man whose property had three mission fig trees on it and was on Paviso's way to the Cupertino Market. Thomas proposed that in exchange for care in his old age, he would leave the Pavisos his land. The land became theirs in 1907 when Thomas died at 96. Paviso built the family a three-room house on the land, adding on to it later. Pictured here is a tax bill for Jason Thomas. (Courtesy Cupertino Historical Society, Paviso files.)

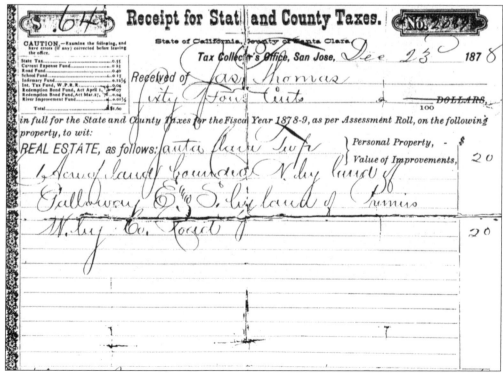

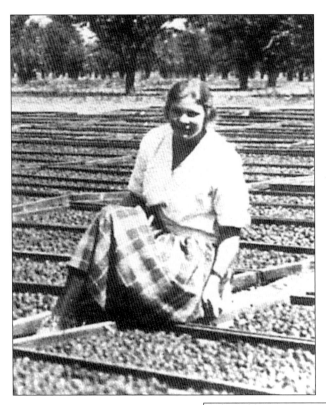

Catherine Paviso picked prunes and "cut 'cots" for drying and worked in Shuckles Cannery with her mother for spending money. She attended the one-room Collins School, graduating in a class of eight girls in 1916. She took the interurban railroad at 7:10 a.m. to San Jose High School, graduating in 1920 and continuing with her higher education at San Jose Normal School. (Courtesy Cupertino Historical Society, Paviso files.)

Louis Paviso, pictured here in 1932, helped his father plow with horses and picked prunes and apricots. He "cut 'cots" until strong enough to became a box boy. Louis graduated from Collins School in 1922, then took the interurban at 7:10 a.m. to San Jose High School, graduating in 1926. He built an airplane out of parts at aviation school and got his pilot's license in 1932. (Courtesy Cupertino Historical Society, Paviso files.)

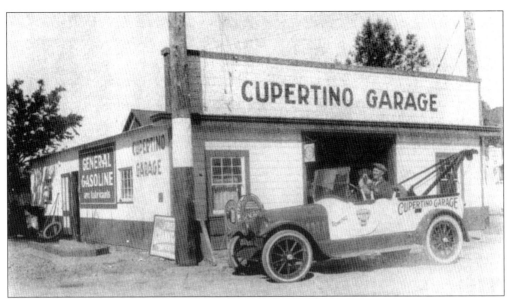

Part of the Paviso acre was sold to Louis Paviso Jr., who built Louis's Garage in 1932. Louis Jr. was also a Gilmore Dealer "Roar With Gilmore." His sister Henrietta was his "gofur" and bookkeeper. When Louis retired in 1965, he leased the garage to the Cupertino Mercedes Services but held ownership of the land. Another part of that acre holds the Doughnut Wheel today. (Courtesy Cupertino Historical Society, Paviso files.)

Louis Paviso Jr. met "Monty" (Violet) at ground school classes at San Jose State College, where she also received her glider pilot license. After graduation, he went to Montana to claim her. They married in 1937, and she helped him in the garage. He was an officer in the Cupertino Improvement Club, the Masons, the Odd Fellows, and the Lions, and a board member of the Fremont Union High School District and the Union Church of Cupertino and Cupertino Chamber of Commerce Man of the Year. (Courtesy Cupertino Historical Society, Paviso files.)

Catherine Paviso married Elija John Gasich during her sophomore year. He came to America in 1909 from Hercegovina and was a protégé of Grant Barton, a local orchardist. After their wedding, he tended an 18-acre orchard on Homestead Road. During their more than 50 years of marriage, the couple entertained, among others, the consuls from Jugoslavia, King Peter of Jugoslavia, the metropolitan of the Serbian Church, distinguished writers, and many others from the Serbian Church. (Courtesy Cupertino Historical Society, Paviso files.)

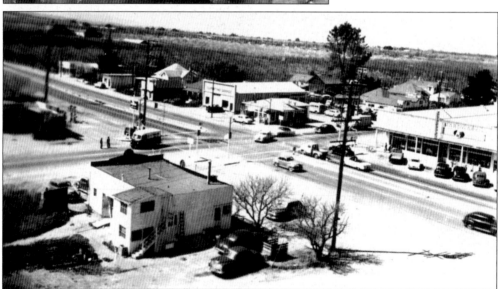

In 1932, the Democratic Central Committee had no applicants for postmaster when Roosevelt was elected, so Catherine Paviso Gasich accepted the job. In 1935, she earned $678 a year at the job, working from 6:00 a.m. until 6:00 p.m. for a six-square-mile area containing 3,000 residents. The part-time clerk and rural carriers earned 25¢ an hour. Mail was hand-cancelled and money orders handwritten. Receipts for 1935 totaled $3,967. (Courtesy Cupertino Historical Society, Paviso files.)

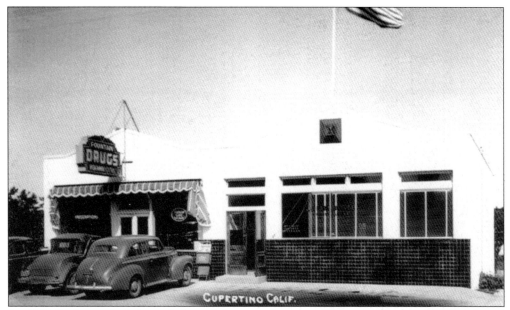

By 1947, Catherine had three clerks and three rural carriers. They moved into a building shared by the first pharmacy, Fountain Drugs, run by Clarence Castro, on the Saratoga-Sunnyvale Road. Receipts in 1954 totaled $63,000 for the year, and the staff included an assistant postmaster, 10 clerks, 3 rural route carriers, 6 city carriers, and 3 substations. A new, larger post office was built in 1962 on Stevens Creek Boulevard. (Courtesy Cupertino Historical Society, Paviso files.)

In 1973, the Cupertino Chamber of Commerce received 20 nominations for Catherine Gasich as Citizen of the Year. Among her qualifications were her 28 years as postmaster (1935–1963) and her leadership with such organizations as the Cupertino Round-up Referral Agency, the Friends of the Library, the Cupertino Historical Society, the Salvation Army, the Soroptomist Club, La Trianon Foundation, the Sierra Club, the Union Church of Cupertino, the King's Daughters Circle, the Mary Martha Circle, the Rebekah Lodge, and the Northwest YMCA. (Courtesy Cupertino Historical Society, Paviso files.)

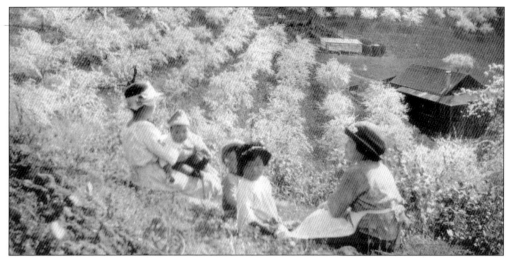

Catherine Paviso wrote, "The apricot blossoms were pretty little apple-like blossoms, pinkish in color, but the prunes, when they bloomed, the whole valley was snow-white, and then this beautiful perfume would come towards you. . . . it was just beautiful. We used to have Blossom Festival Days in the olden days, usually in mid-March, which were held in Saratoga. People from all around the Bay Area came to our valley to enjoy them." Bessie Iwagaki, on the left, is pictured having a picnic among the blossoms with a friend and their children. (Cupertino Historical Society, Paviso and Iwagaki files.)

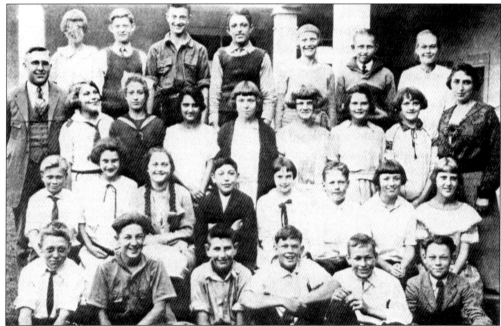

Henrietta Paviso, the baby of the family, played with her dolls on a mound of hay while the older children "cut 'cots." Later she took her turn at cutting cots and working in the cannery. She attended the second Lincoln School, Fremont High School, and San Jose State College. She worked for Louis Jr., then the Cupertino Post Office delivering mail. Henrietta is pictured here (third row, left end next to the teacher) with her grammar school class. (Courtesy Cupertino Historical Society, Paviso files.)

Henrietta Paviso Marcotte celebrated her 80th birthday with old classmates from 1921 to 1929. Pictured, from left to right, are (first row) Hazel Regnart Fretwell, Thirza Hinkley Quant, and Gertrude Botil Ciumarta; (second row) Mathilda Mariani Sousa, Mildred Burtner Martin, Bernadeen Berger Wirthlin, Steve Jugum, and Henrietta. She started the Trunk Program for young people to bring artifacts and explain the "olden days" to schoolchildren. She promoted local history and wrote the history column for the city's *Cupertino Scene* for years. (Courtesy Cupertino Historical Society, Paviso files.)

The Camarda family started growing apricots in the county in the early 1900s but, by 1976, was farming 100 acres rented from the Cali brothers and had a seasonal apricot drying yard. Peter was a real estate broker, and Joseph Jr. was the transportation supervisor for the Cupertino Union School District in 1976. In the background is a rising building. Peter Camarda claimed that the Santa Clara County apricots were better tasting than those from Patterson. (Courtesy Cupertino Historical Society.)

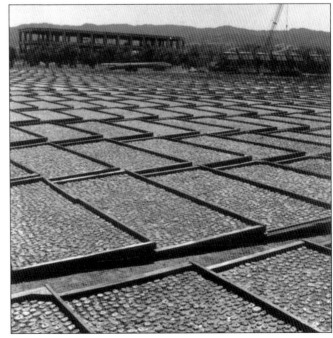

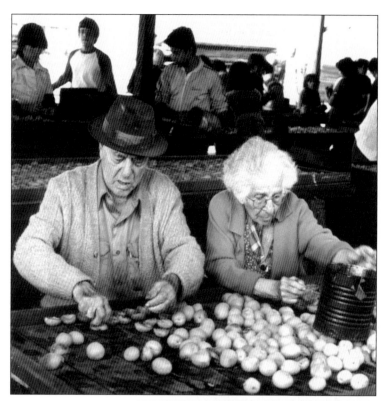

Joseph Sr. and Rose Camarda (pictured here at ages 96 and 87, respectively) "cut 'cots" on the last day at their 21-acre drying yard on Stevens Creek Boulevard next to Cali Mill on July 17, 1983. They had both come from Sicily as children, had lived in their home for 41 years (purchased in 1930 for $8,500), and were married for 69 years. (Courtesy Cupertino Historical Society.)

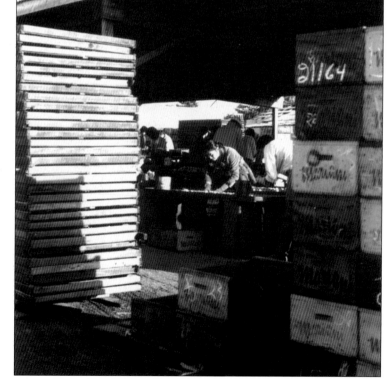

This image was taken on the last day at the Camarda Drying Yard. Fresh-picked apricots came in the lugs at the right, were cut in half for drying, and were placed on the drying flats on the left. They were then sulfured overnight and laid out in the sun to dry. (Courtesy Cupertino Historical Society.)

# Seven
# MONTA VISTA

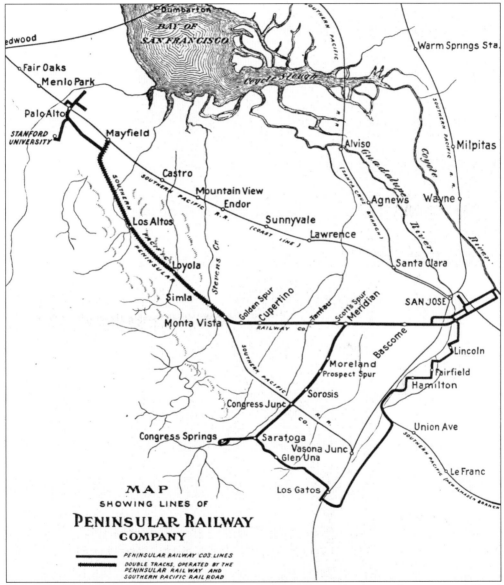

MAP
SHOWING LINES OF
**PENINSULAR RAILWAY**
COMPANY

PENINSULAR RAILWAY COS. LINES
DOUBLE TRACKS, OPERATED BY THE
PENINSULAR RAIL WAY AND
SOUTHERN PACIFIC RAIL ROAD

When the Peninsula Electric Railroad was buying up property adjacent to Stevens Creek Road to extend their line, some neighbors donated land, and others accepted small sums, but Elizabeth McAllister MacLeod from Scotland held out for $3,000 as the value of the land. She moved a small building onto the right-of-way and slept in it with her shotgun. A few days later, an agent offered her $2,975, which she accepted. (Courtesy Cupertino Historical Society.)

The Southern Pacific Railroad established a line through this area in an effort to bypass San Jose and get to Los Gatos with the destination of Santa Cruz in mind. Later it transported commuters from this area and Los Altos to connect with the main line in Palo Alto. Students also used it to go to high school in Palo Alto. Fremont Older and Painless Parker were among the commuters. (Courtesy Cupertino Historical Society.)

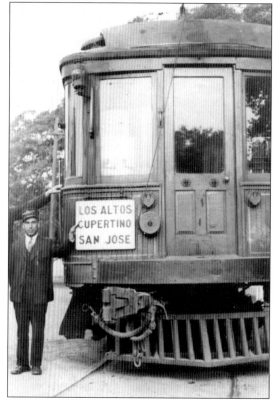

The Peninsula Electric Railway Company installed a connection to San Jose from the Southern Pacific Railroad route at a sign that was labeled Monta Vista, about 1905. Students used this streetcar line to go to high school or college in San Jose, as did those who needed to go for business reasons. Others took it to Saratoga for the Blossom Festival and the picnic areas. (Courtesy Cupertino Historical Society.)

After vineyardist John T. Doyle's death, developer George Hensley purchased 450 acres and gave some subdivisions elegant names: Subdivision A, Monta Vista Subdivision B, The Colony Tract, Altos Park, First Addition, Monta Vista Park, Las Palmas, Russelhurst, Colony Tract, Inspiration Point, Inspiration Heights, and Ninth Addition. A residence built about 1910 was dedicated as the Monta Vista Country Club. (Courtesy Cupertino Historical Society.)

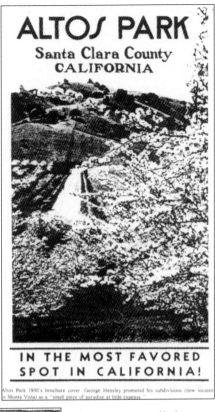

**ALTOS PARK**
Santa Clara County
CALIFORNIA

**IN THE MOST FAVORED SPOT IN CALIFORNIA!**

Altos Park 1930's brochure cover. George Hensley promoted his subdivisions (now located in Monta Vista) as a "small piece of paradise at little expense."

A movement called "Little Landers" entailed a scheme to sell a "little land" to people who could raise chickens, vegetables, and fruit and be self-sufficient. Promoter George Hensley, an Olympic Club amateur wrestling champion, planned for Monta Vista to be one of those colonies; however, he ignored zoning requirements and ended up with various-sized lots. His streets were graded dirt with inadequate water pipes. His promotions to busloads of San Franciscans for summer homes were free picnics with flags and bunting. (Courtesy Cupertino Historical Society.)

Hensley ballyhooed "a small piece of paradise at little expense," but his plats were uneven in size, from 25-by-100-foot lots to 5-acre lots. He also touted the area's vineyards, country club, waterworks, pumping plant, excellent rail and road connections, mild climate, the cannery and railroad property next to the existing station, ranch lands, orchards, and wineries. He even claimed that the area could boast sunny weather 74 percent of the time over the previous 24 years. (Courtesy Cupertino Historical Society.)

The Monta Vista Waterworks began with a well in Stevens Creek with inadequate piping. The reservoir, built in 1935 and pictured here, impounded only in the winter, which meant dry summers. Other wells were drilled as demand grew. Chester Damico reorganized the system, calling it the Water Works of Monta Vista, Ltd. He installed meters, and it began to be self-sufficient. On April 1, 1960, the Water Works of Monta Vista, Ltd., was dissolved and all assets sold to the City of Cupertino. (Courtesy Mary Lou Lyon.)

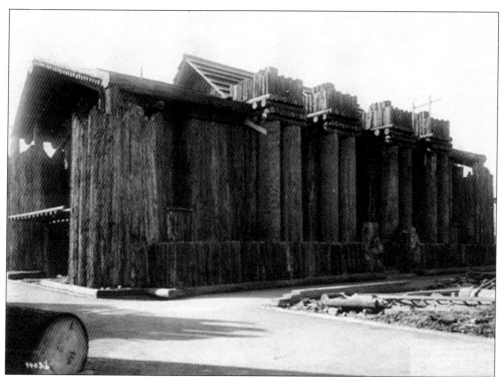

Hensley purchased the "Hoo-Hoo House" in 1917 when the San Francisco Exposition ended. The facade had eight log columns, which were each 26 feet high and 42 inches in diameter, and weighed 8 to 10 tons, representing the eight commercial woods of the Pacific Coast: redwood, sugar and white pine, Douglas fir, Western hemlock, Western spruce, and red and Port Orford cedar. The structure was erected on Inspiration Point, or Hoo-Hoo Hill, where car owners came to test their cars. (Courtesy Rick Helin.)

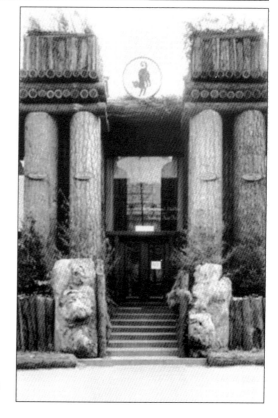

The International Concatenated Order of Hoo-Hoo was organized in 1892 for those employed in the forest products industry, including those working in forestry, sawmilling, research, education, manufacturing, and marketing of all wood-based products. The building interior was Gothic and finished by multiple waxings of the commercial coast woods, redwood, sugar pine, white pine, and Douglas fir. The building was used as a country club. It burned to the ground on August 16, 1928, in a spectacular fire. (Courtesy Rick Hellin.)

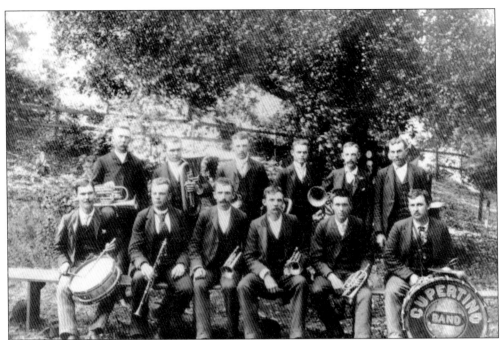

The Cupertino Band included Gus Williams, singer and baritone horn; J. D. and May Williams, violins; Liss Williams, piano; Al Williams, cornet; Ed Stelling; Jack Crosley; Gabriel North; Hal Lydiard; and Joe Wolfe on bass drum. Norman Nathanson was sometimes featured on saxophone. They played at the Hoo-Hoo House for a dance put on by Monta Vista Estates, Inc., every Saturday night. No liquor was permitted, and no intoxicated person admitted. No girls under 18 were allowed entrance without a chaperone. (Courtesy Cupertino Historical Society, Williams files.)

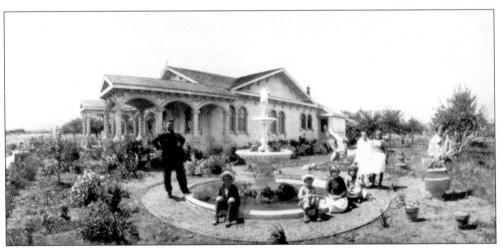

Federico Quinterno, a sculptor and stonemason from northern Italy, came to work on the Palace of Fine Arts for the 1915 Panama-Pacific International Exposition. Pictured here, from left to right, are Federico, Angelo, Paul, unidentified girl, Nellie, unidentified friend, Adriana, and Francesca. He moved to Cupertino when he worked for Cora Older, building a stone grotto and walls. He built an ornate rock house for his family after doing the work for the Olders, Painless Parker, and Seven Springs Ranches. (Courtesy Cupertino Historical Society.)

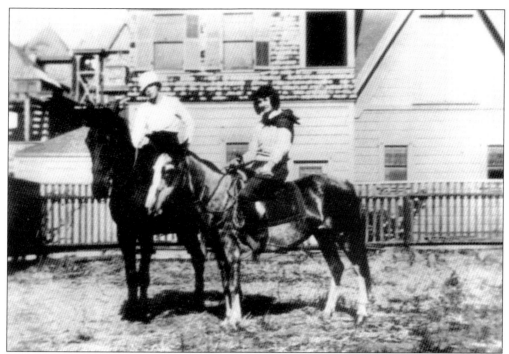

The Quinterno children also worked for Cora Older and at the Hoo-Hoo House. Pictured on the right, Adriana, Cora's favorite, was sent to Notre Dame High School by the Olders. At age nine, she sold candy, gum, and ice cream from a wheelbarrow that she pushed to a small stand near the Southern Pacific Railroad tracks and Stevens Creek Road. After graduating high school, Adriana went to work for the Los Gatos paper and for Cora's brother, Hiland Baggerly. (Courtesy Paula Quinterno.)

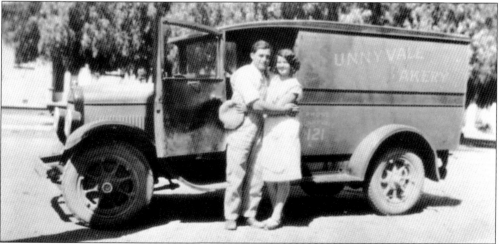

Adriana and Charles Rifredi are pictured here on the occasion of their wedding in 1929. Adriana gave up her writing for the Los Gatos paper and married a Sunnyvale delivery boy. She borrowed $300 from his boss and rented a little store on the corner opposite the grammar school and sold candies, gum, and a few groceries. In the early 1930s, the couple bought land in "downtown" Monta Vista and built Rifredi's Market, which was 32 feet wide by 50 feet deep and provided them with living quarters in the rear of the store. (Courtesy Paula Quinterno.)

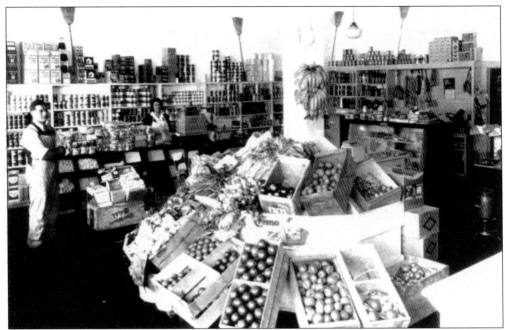

Pictured here is the interior of Rifredi's Market with Angelo Quinterno and Charles Rifredi, who was also the butcher. Angelo ("Cheet") Quinterno, pictured on the left, married Linda Pianto in 1937 and became a partner in the grocery store in the 1940s. In the late 1940s, they built a larger store next to the old one, employing 10 people at one time. The couple had three daughters: Nola, Faye, and Paula. When Charles Rifredi retired, his eldest son, Robert, became a partner with Angelo. (Courtesy Cupertino Historical Society.)

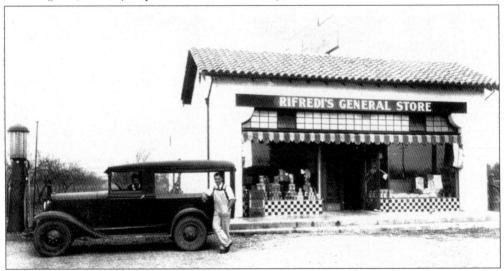

The gas pump in front of Rifredi's Market, pictured here with Angelo Quinterno and Charlie Rifredi, later gave way to a Shell station next door that was run by Paul Quinterno. He was always happy to help a youngster repair a flat bicycle tire. He and Charlie Baer, who operated the only gas stations in town, served Model Ts and Hupmobiles and sold gas for 17¢ a gallon. During the gas shortage, Quinterno advised lining up cars at night at the station since they ran out of gas after a couple of hours. (Courtesy Cupertino Historical Society.)

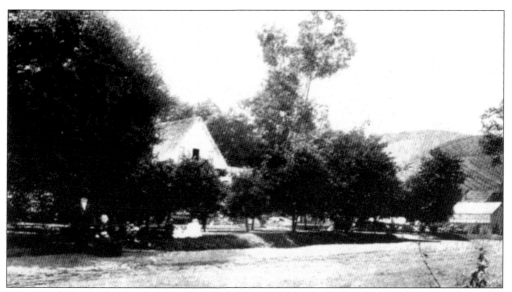

John P. Bubb's overland party arrived in California on September 20, 1849, settling in Kelseyville. The Bubb house was on Stelling and Prospect Roads in 1876 at Seven Springs Ranch. John Bubb claimed that when he bought his land, it was so poor that a jackrabbit would have starved on it. The main products of the soil were mustard and squirrels, the roads were trails, and the land was expensive at $40 an acre. Bubb was instrumental in forming the Lincoln School District in 1865 and served as a trustee for 21 years. (Courtesy Cupertino Historical Society.)

Dr. and Mrs. McDougal are pictured here with Harry and Bess Iwagaki. Herman Henry Voss worked as foreman for Dr. McDougal on Regnart Road. He bought 16 acres nearby, setting out prunes and apricots and building a simple house where he and his wife, Caroline, and their nine children lived until 1963. He became a U.S. citizen and participated in the development of local public schools, serving as a trustee. In 1907, he built St. Joseph of Cupertino Catholic Church, where he sang tenor. (Courtesy Cupertino Historical Society, Iwagaki files.)

Pictured here at Lincoln School are Elizabeth Voss, ? Voss, Esther Olsen, Caroline Olsen, James Griffin, Dorothy Barton, Nellie ?, three unidentified, Georgine Griffin, Mary Griffin, Nellie's sister, and two unidentified. On Sundays, cousins, schoolmates, and neighbors came to the Voss Farm for games, hikes, or horseback rides. They played kick the can, run sheep run, prisoner's base, keep-away, baseball, tap the finger, and hoop driving, often with H. Henry Voss in the middle of their games. One had to climb a large oak tree and slide off the end of the branches, climb the pipe to the windmill, and slide down the rope from the hay loft to be "in." (Courtesy Cupertino Historical Society.)

Florence Anthony, an arthritic spinster, lived next door to the Vosses with her brother Walter in a home surrounded by large oaks and many kinds of fruit trees—orange, lemon, fig, apple, persimmon, olive, mulberry, and more. While harvesting the fruit for the Anthonys, the Vosses found a jug of the best wine in a large hollowed-out oak tree where Walter had hidden it from his Prohibitionist sister. They verified the quality by tasting it, but their father, H. Henry Voss, made them return the jug to help Walter cope with his sister. (Courtesy Cupertino Historical Society.)

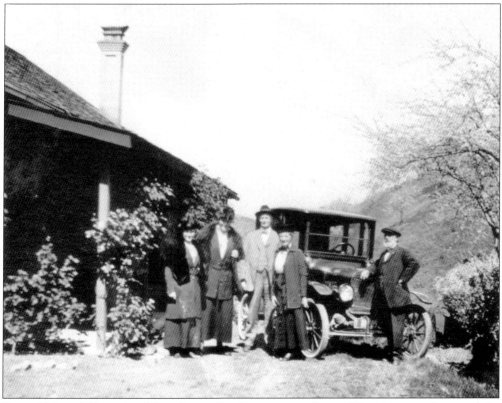

Dr. and Mrs. McDougal and friends pose for the camera in front of their house and automobile. Dr. McDougal is on the right, and his wife is standing next to the automobile. The others are unidentified. The photographer was Harry Iwagaki, who worked for the doctor. (Courtesy Cupertino Historical Society, Iwagaki files.)

Bessie Iwagaki and friend Mr. Moromoto are pictured in a buggy during a visit to Dr. McDougal's home. Harry and Bessie worked for Dr. McDougal at his hillside home. Note the wooden bridge over the creek. (Courtesy Cupertino Historical Society, Iwagaki files.)

Duncan and Amy Iwagaki were photographed at Dr. McDougal's apricot ranch in the foothills in 1924 by their father, Harry Iwagaki, who worked on the ranch. Note the slope of the orchard in the background. (Courtesy Cupertino Historical Society, Iwagaki files.)

Alvin R. Carter (possibly at age two) is pictured with a team in 1917. Alvin and his brothers Clifford and Chester grew up on their grandfather's prune, apricot, and walnut ranch on Bubb Road where their father worked as foreman. The boys learned to drive horses, a Model T truck, and a Holt tractor in 1923. Their first car was a Model A Ford with a rumble seat. They went to local schools. Alvin was postmaster from 1964 to 1979 and Citizen of the Year in 1979. (Courtesy Cupertino Historical Society.)

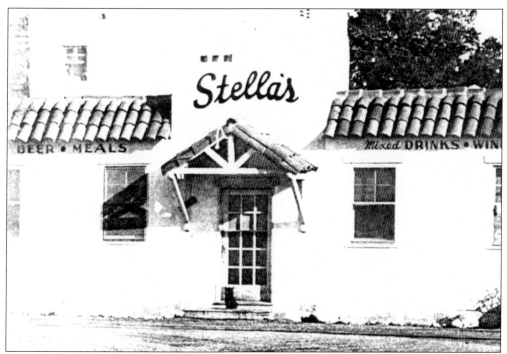

Stella and William Kester visited Monta Vista with their friend George Hensley in 1917. Stella described the area as a beautiful flower garden and said that she felt like a big investor when she bought several lots. The couple opened a bar at the hairpin turn on McClellan Road in 1933, and it became a gathering spot and watering hole for quarry workers, prune pickers, farmers, horsemen, and visitors to the area. (Courtesy Cupertino Historical Society.)

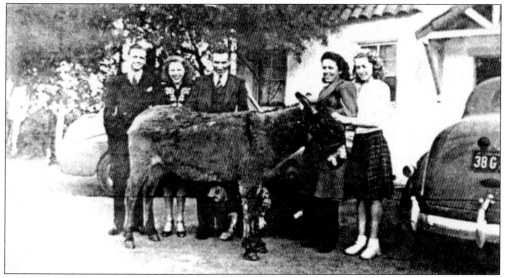

In 1942, Stella Kester closed the bar and joined the Women's Army Corps. She was a driver in the motor corps in France and Germany and was discharged in 1947 after four years and nine months of service. After her discharge, she reopened the bar. There was a sign on the bar that said, "For a dollar, see Stella's ass." A stranger would hand her a buck, and she would take him around to the back where her jackass was kept. (Courtesy Cupertino Historical Society.)

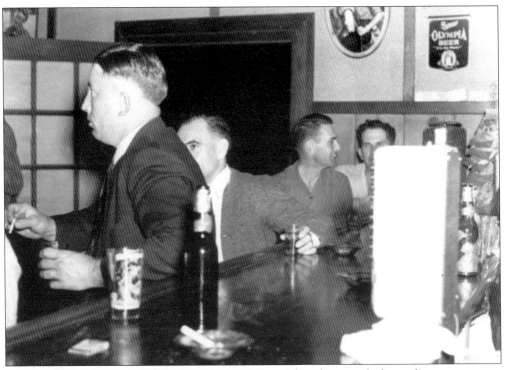

This photograph shows the interior of the bar. Sometimes patrons struck up a tune on the piano, which led to impromptu dancing. Stella Kester also owned a pet raven who could be heard clearly when the phone rang, calling out, "Stella, Stella, answer the phone." Stella sold her liquor license in 1969, began operating an antique shop on the property, and moved to a ranch on Stevens Canyon Road in 1971. (Courtesy Cupertino Historical Society.)

In 1979, Stella died of cancer at the Palo Alto Veteran's Hospital. She had lived on her military pension and hadn't filed income tax returns, even after starting to sell her land, which she had a lot of. Her will left $10 each to a son and grandchildren, but $50,000 was provided for care of her animals. That was "adjusted" fairly and the IRS paid, leaving a charitable trust of $1.4 million for various organizations. (Courtesy Cupertino Historical Society.)

# *Eight*
# EARLY SCHOOLS, CHURCHES, AND ORGANIZATIONS

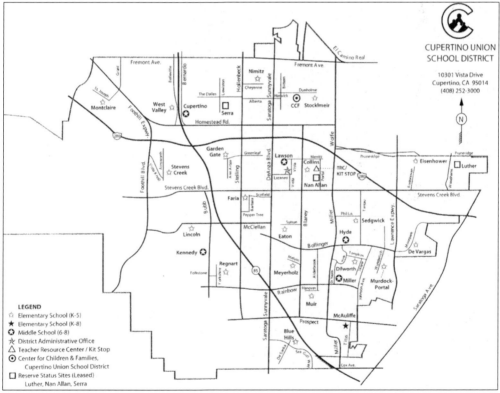

The State of California passed a school act in 1865 that gave funding to local public schools according to population. Schools also had to be two miles apart, which gave Cupertino the right to four schools. The state paid the teacher, but local residents paid for the land and building. Later the state offered subsistence for the construction of a building as well. The Cupertino Union School District looked like this in 2000.

The first school, in 1864, had no name. The McClellan children in that year included Phoebe (age 15), Columbus (12), James (10), Joseph (8), Frank (6), and Grace (2). Another 22 children at the school came from other area families, including the Hanrahans, Thomases, McCauleys, Anthonys, Clearys, Duncans, Wallaces, and Plunketts. The McClellans located a teacher, Sarah Brewer, and converted a shed by the creek into a classroom. (Courtesy *Adventure Valley* by Ralph Rambo.)

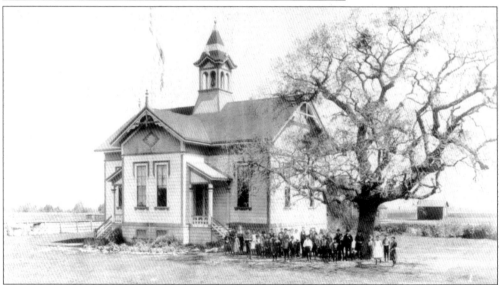

The first official Cupertino School was Lincoln, which was built in 1865 on one-and-a-half acres contributed by S. P. Taylor at Prospect and Sunnyvale-Saratoga Roads. In 1871, Peter Ball offered a superior lot across the intersection. He waited until Taylor left, then harnessed his team of draft horses to ropes and rollers and, with other neighbors, dragged the school building across the road, where it would remain. This second building was constructed in 1888. (Courtesy Cupertino Historical Society.)

Hazel Regnart remembered studying reading and penmanship very well. The students had little books with samples. They made circles, starting out with pencils and eventually graduating to straight pens with pen points stuck in them. The students also had to make pen wipers because they had to wipe off the points every time they used them. Inkwells fit on the right side of the desk, where many long braids were dipped. (Courtesy Tim Peddy.)

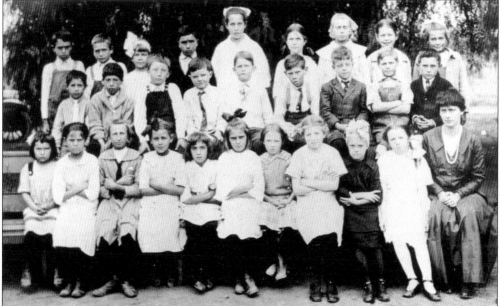

Hazel Regnart remembered at age 95 that children mostly played tag at recess since they had very few balls to play with. Older children went down behind the school to play in the creek, and there was a high fence separating the small kids from the bigger ones. Every September, children would go to San Jose to get one or two dresses or Levis and shirts for boys at Hart's Store. They went to Harry Silver for shoes—one size too large so they would last all year. (Courtesy Cupertino Historical Society.)

San Antonio School was built on Rancho San Antonio property. In 1867, William Dale donated two-and-a-half acres. Dale, Joseph Barton, T. F. Grant, John Snyder, and others built the school with local lumber supplied by Barton. John Snyder boarded and paid the carpenters, and Will Dale made eight rows of desks, plus a raised platform for the teacher. The classroom was supplied with three walls of chalkboards and a potbellied cast-iron stove. (Courtesy Cupertino Historical Society.)

San Antonio was on the wooded bank of a little creek. Grant Barton, son of Joseph Barton, was hired to oil the windmill gears once a month, but he began visiting the school several times each week during recess. Soon he was engaged to schoolteacher Elizabeth Doten. Pictured here in 1900 are Grant Barton, Herbert Pash, Ruth Barton, and ? Barton, crossing the creek on a swinging bridge. The building still stands, but it is attached to a private residence. (Courtesy Cupertino Historical Society.)

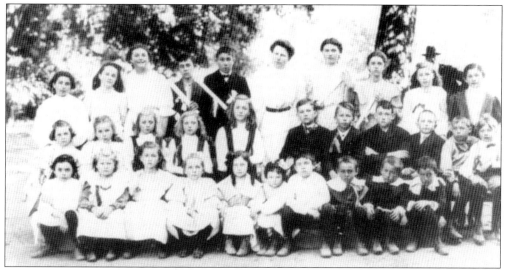

These San Antonio School students, pictured in 1906, from left to right, are (first row) Brigid McKenzie, Evelyn Olsen, Amanda Olsen, Marie Voss, unidentified Sellinger, Ellen McKenzie, John McKenzie, and three unidentified; (second row) Mabel Williams, Clara Voss, Mary Smith, Francis Smith, Marguerite Smith, Dave Everett, Albert Olsen, George Sellinger, Joseph Voss, Alphonso Stocklemier, and Percy Smith; (third row) Adele Stocklemier, Lucy Heney, Jeanette Smith, Carl Schoppe, Louis Stocklmier, teacher Susie A. Corpstein, Irene Smith, Lizzie Snyder, Mabel Olsen, and unidentified. (Courtesy Cupertino Historical Society.)

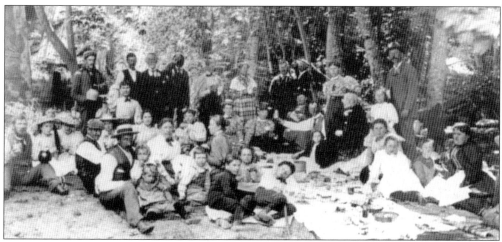

When young Louis Stocklmeir graduated from San Antonio School in 1906—one of only four graduates that year—all pupils and the teacher rode to school on horseback or in a buggy. Lizzie and Lonzo Snyder rode their saddle horses a mile across their ranch to the school. Students vied for the honor of unhooking the teacher's horse and leading it to the stable, but the real prize was being allowed to wind the octagonal railroad clock every eight days. (Courtesy Cupertino Historical Society.)

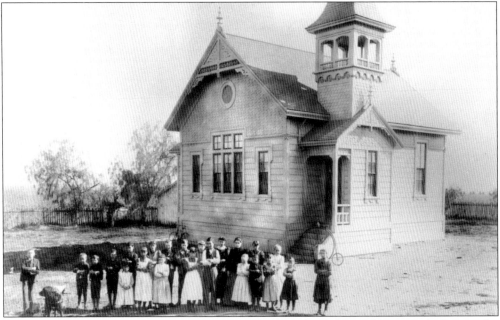

In 1869, the first one-room Collins School was built on land donated by L. P. Collins at the corner of Sunnyvale-Saratoga Road and Young Road (now Homestead). Carol Murdock was the first principal. In 1889, a more modern one-room school was designed by J. O. McKee and built on the same site by Enoch Parrish. This photograph was taken in 1894. (Courtesy Butcher family archives.)

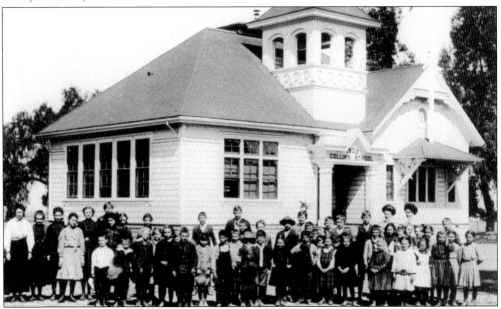

In 1908, the architectural firm of Wolfe and McKenzie planned an addition on the west side of Collins School, and it was built by Enoch Parrish. The design called for the removal of the old bell tower and the addition of the current tower between the two rooms, while retaining the 1869 bell and adding fish-scale shingles. The architects also added a bank of windows on the east side to make a more modern second classroom. (Courtesy Cupertino Historical Society.)

The 1882 Doyle School was the fourth school in Cupertino. This one-room school had grades one through eight with 20 to 40 students. When the district tried to sell the land to the state for the freeway, they discovered a reversion clause, which gave the land back to the Doyle family, but the school was torn down and the freeway constructed. A new school now bears the name Peter Doyle. (Courtesy Cupertino Historical Society.)

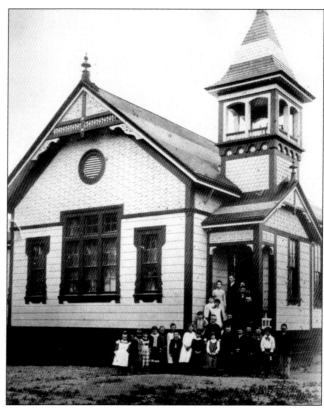

One of the best-known graduates of Doyle School was Ralph Rambo, who graduated from Santa Clara High School in 1912, attended the San Francisco School of Fine Arts, and then enrolled in a correspondence cartoon course. A job he began at the Muirson printing plant in 1916 lasted until 1966. Rambo designed labels for canned fruit. Eventually he became the art director with a staff of eight, turning out five million canning labels a day. (Courtesy *Pen and Inklings: Nostalgic Views of Santa Clara Valley* by Ralph Rambo.)

Rambo didn't like the way history was taught: "It was too dry, memorizing dates, names, battles, without any amusing description of the way of life." When he looked for a nostalgic book on life in the early 1900s, he couldn't find any for his grandchildren, so he began writing them himself. For a treat in early-1900s life in the valley, find his books *Almost Forgotten, Remember When,* and *Adventure Valley.* (Courtesy *Pen and Inklings: Nostalgic Views of Santa Clara Valley* by Ralph Rambo.)

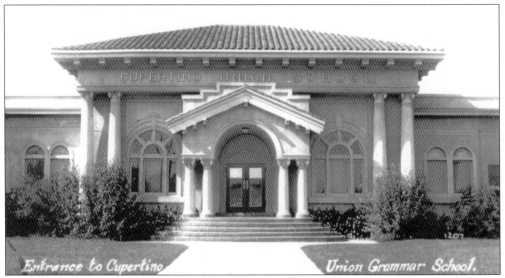

In 1917, I. A. Ball, Warren E. Hyde, Herbert Pash, and Arch Wilson—representing the original four one-room school districts, Lincoln, San Antonio, Collins, and Doyle—met in 1917 to organize the Cupertino Union School District. The Union School opened in 1921. Darryl J. Sedgwick was principal of the Cupertino Union School for nearly 30 years, as well as the first superintendent. He also led the orchestra, taught manual training, and taught physical education for the upper grades. (Courtesy Cupertino Historical Society.)

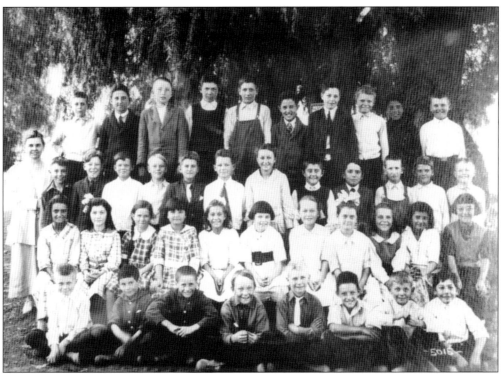

As a child, Mabel Williams, the daughter of Gus and Adda Williams, had attended San Antonio School; in 1919, she was the teacher at Collins School. She moved with the children to the new Union School in 1921, when the four original schools were consolidated into the Cupertino Union School District, and she continued teaching there until her marriage in 1937. (Courtesy Cupertino Historical Society, Williams files.)

This is the Cupertino Union School graduating class program of 1924. Darryl J. Sedgwick spent his entire summer vacations at the school refinishing and repairing the desks and furniture. When school reconvened, he made a new rule that no gum could be chewed in school because he had wasted much of his time scraping it off the bottom of the desks. He took the graduating class of 1917 to Santa Cruz—only 12 students. (Courtesy Cupertino Historical Society, Williams files.)

**Graduating Exercises**
of
**Cupertino Union School**
Thursday Evening, June 19, 1924.
‑‑‑❖❖❖‑‑‑

**PROGRAM**

1. March—Merry Hearts . . . . . . . . . . . . . . *H. O. Wheeler*
   Cupertino School Orchestra.
2. Overture—Little Corporal . . . . . . . . *L. P. Laurendeau*
   Cupertino School Orchestra.
3. Address of Welcome . . . . . . . . President Mildred Burtner
4. Class History . . . . . . . . . . . . . . . . . . . . . . . . . Leah Groff
5. Class Will . . . . . . . . . . . . . . . . . . . . . . . Mary Wagnitz
6. Chorus—Barcarolle . . . . . . . . . . . . . . *Halfdan Kjerulf*
7. Class Prophecy . . . . . . . . . . . . . . . . Florence Abernathy
8. Reverie—Brownie's Story . . . . . . . . . . . . . . . *Jean Faber*
   Cupertino School Orchestra.
9. Class Poem . . . . . . . . . . . . . . . . . . . . . . . Hazel Regnart
10. Presentation of the Class Gift . . . . . . . . . Clarence White
    Accepted by . . . Edgar Johnson, President of Student Body
11. Class Song—Remembering.
12. Address to the Graduates—
    Frank Campbell, Attorney-at-Law.
13. Presentation of Diplomas—
    Principal Darrel J. Sedgwick.
14. March—Aviator . . . . . . . . . . . . . . . . . *C. W. Bennet*
    Cupertino School Orchestra.

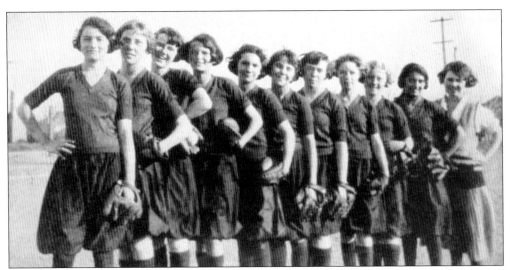

The 1924 Cupertino Union School girls' softball team included, from left to right, Lena Mardesich (Bonacich), Mildred Burtner (Martin), Mary Wagnitz (Kehl), Pauline Wilson (Woodruff), Mathilda Mariani (Sousa), Henrietta Paviso (Marcotte), Antonette Conforti, Thelma Fulton, Ruth Montgomery (Jackson), Bessie Gallard, and Mabel Williams (Noonan), the physical education teacher. (Courtesy Marcotte family archives.)

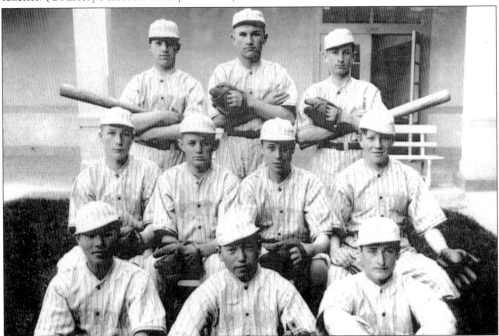

Pictured here is the 1924 boys' baseball team at Fremont High School. From left to right are (first row) Mitsumo Yamata, Taro Kishimino, and Florian Musladen; (second row) Everett Spaith, Oscar Clay, James Venten, and Lester Johnson; (third row) Veriss White, Pete Summer, and "Wig" Breezink. The first school in the West Side Union High School District was organized in September 1921. The school started on May 2, 1923, in rooms of the Sunnyvale Grammar School building. The board hired Leslie G. Smith as principal at $125 per month, two teachers for $225 and $200 per month, and a "janitress" for $35 per month. (Courtesy Cupertino Historical Society.)

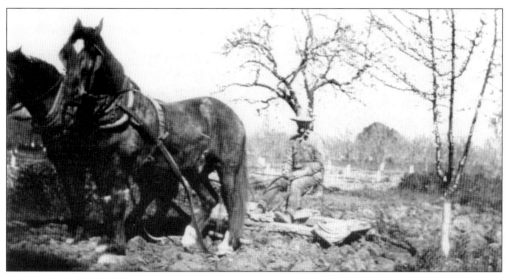

Marty Mathiesen was born in Cupertino in 1911, of Danish parents who treasured education. He attended Doyle, Collins, and Cupertino Grammar Schools, Westside Union High School, San Jose State, and University of California at Berkeley. He taught at Marysville High School, Williams High School, Eureka High School, and Humboldt State University before returning to Cupertino to help his mother and hiring on with the Fremont Union High School District as teacher and coach. Marty was the first principal at Sunnyvale High in 1956. (Courtesy Butcher family archives.)

Marty Mathiesen, pictured here with the historical society's parade entry car, helped plan Cupertino High in 1958, then became assistant superintendent for finances in the Fremont District and, in 1974, acting superintendent. In retirement, he held a state-level office in the California Retired Teachers' Association prior to being appointed to a four-year term on the State Teachers Retirement Board in 1996 and being reappointed in 2000. Mathiesen retired at the age of 91 because of ill health, and he passed away in 2004, leaving a hole in the educational community. (Courtesy Cupertino Historical Society.)

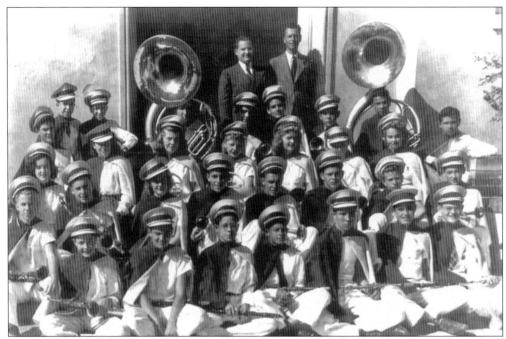

Members of the Fremont High School band pose here in 1922. Verne Hall was hired as principal of Fremont High School for the 1925–1926 school year at a salary of $3,600 per year. The board of trustees unanimously voted to change the name of the high school to Fremont Union High School in the Fremont Union High School District. The district office was built adjoining the high school on West Fremont Avenue in 1960–1961. (Courtesy Cupertino Historical Society.)

When the Foothill Junior College District's second campus was built in Cupertino, they looked for a historical name. The Cupertino Chamber of Commerce, among others, suggested De Anza, which was selected in April 1963. Today the campus on the old Admiral Baldwin property is an integral part of the community, educating over 22,000 students and including two historic properties on its busy campus. This is a view of Flint Center across Stevens Creek Boulevard. (Courtesy Mary Lou Lyon.)

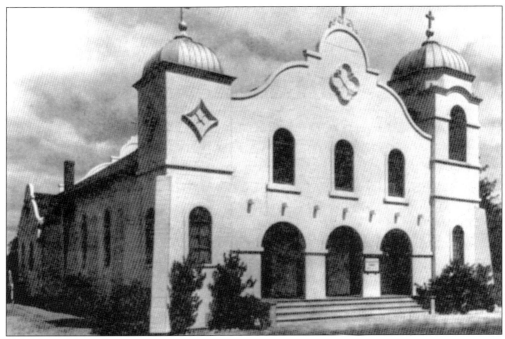

Catholics in the area worshipped at the Villa Maria, a summer retreat for the Fathers of Santa Clara University since 1873. In 1907, Alexander Montgomery donated an acre of land, and Henry Voss and John McCarthy led the building of the first St. Joseph of Cupertino Church, pictured here, under Father Gabriel. Groundbreaking was held on October 11, 1907. The building, which held 180 people, cost $9,000 and served the parish for 46 years. (Courtesy Cupertino Historical Society, St. Joseph files.)

Here is the second St. Joseph of Cupertino Church in 1954. The congregation outgrew its original church, so additional acreage was bought and architect Vincent Raney of San Francisco was hired. The cornerstone of the new building was laid on Sunday, April 12, 1953. The 550-person-capacity church was built by Wells P. Goodenough of Palo Alto at a cost of $140,000, with an additional $50,000 required for the interior and fixtures. (Courtesy Cupertino Historical Society, St. Joseph files.)

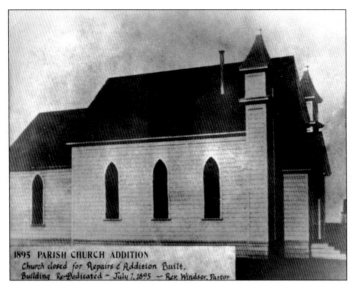

1895 PARISH CHURCH ADDITION
Church closed for Repairs & Addition Built.
Building Re-Dedicated ~ July 7, 1895 ~ Rev. Windsor, Pastor

The members of the Union Church of Cupertino first met in homes on Sunday afternoons in 1867 and then at San Antonio School as a mission of the Cumberland Presbyterian Church. They built a small church on an acre of land that Alexander Montgomery had donated. Enoch Parrish built the first church for them for $1,600. When it was dedicated on March 30, 1884, they were debt free. (Courtesy Union Church of Cupertino History Room and Tim Peddy.)

The congregation closed the mission church, returning $300 to Cumberland Presbyterian Church because the Cumberland Presbyterians did not condone organ or piano music. They filed papers to incorporate as an independent Union Church of Cupertino on May 26, 1888, and the articles of incorporation were signed by J. C. Merithew, D. H. Blake, Joseph D. Williams, Alex L. Harrison, and John P. Crossley. (Courtesy Union Church of Cupertino History Room and Tim Peddy.)

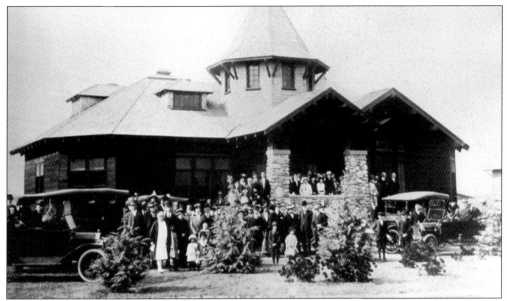

A parsonage was built for Union Church of Cupertino in 1903 for $1,200. After the earthquake of 1906, they agreed to build a second church, and dedication of the larger building took place on July 3, 1910. The final cost was $6,600 for the second sanctuary. Alex Montgomery contributed $5,700 to build a church annex for a Sunday school in memory of his wife in 1922. The Sunday school superintendent in 1910 was Dora Rambo. (Courtesy Union Church of Cupertino History Room and Tim Peddy.)

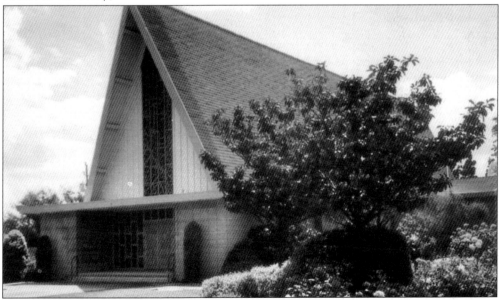

The congregation weathered the Great Depression and grew as the community grew, beginning in the 1950s. The 50-year incorporation expired, so the board reincorporated on November 29, 1950, in perpetuity. Arch Wilson offered to exchange four acres on Stevens Creek Road and $31,500 for the one-acre site on Sunnyvale-Saratoga Road he wanted for the Crossroads Shopping Center. The dedication of the third sanctuary on Stevens Creek Road, seating 400, was held on December 7, 1958. Membership at that time was 545. (Courtesy Union Church of Cupertino History Room.)

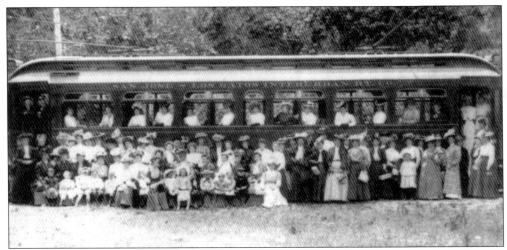

Mrs. Fanny Jollyman and nine other ladies met at the Jollyman home in 1887 to organize a chapter of the King's Daughters, a non-sectarian international organization. Here they are in a rail car in Saratoga on an outing. The group's motto was, "Look up, not down, Look forward, not back, Look out, not in, And lend a hand In His name," and their main aim was to aid the poor and shut-ins. (Courtesy Cupertino Historical Society.)

Maryknoll, peering over I-280, was built by missionaries to Asia in 1924 on the San Francisco Catholic Diocese land. Originally designed as a seminary for Catholic missionaries, today the building houses retired priests and brothers of the Maryknoll order. At its peak, the order had 4,000 missionaries serving in Asia, Latin America, and Africa. The only Chinese aspect of the building is the pagoda roof on the tower of the north wing of the building. (Courtesy Tim Peddy.)

St. Joseph's Seminary students were transferred to St. Patrick's in Menlo Park after the earthquake of 1989 significantly damaged St. Joseph's buildings. The archdiocese preferred to spend its money on the rebuilding of St. Joseph's Cathedral in downtown San Jose, so a large section of the property was sold for an upscale senior housing site, the Forum. A significant section adjacent to the Open Space District is dedicated as the Gates of Heaven Cemetery. (Courtesy Tim Peddy.)

The Cupertino Independent Order of Odd Fellows Lodge No. 70 was organized on April 15, 1899. Its charter members included Dr. Edwin Harvey Durgin, noble grand; J. D. Williams, first vice grand; Oscar B. Wood, recording secretary; Fred E. Goodrich, first conductor; William T. Baer, first financial secretary; Herbert Pash; and Augustus Williams. The Philotesian Rebekah Lodge No. 145 was also organized in 1899. (Courtesy Cupertino Historical Society.)

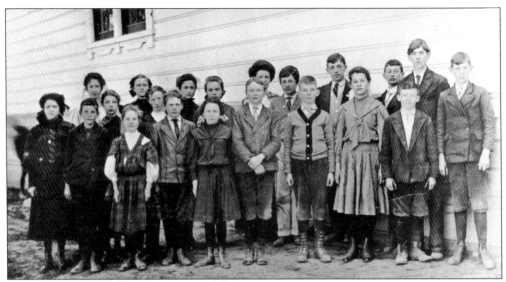

Schoolchildren at Collins School are pictured here in 1908–1909. Pictured with principal and teacher Anita Quinn are students from the fifth through eighth grades. From left to right are (first row) Florence Burrows, Max Herwig, Alice Williams, Elliot Miner, Norma Arment, Lawrence Abel, Johnny Krieg, Lyla Baer, Bryan Dow, and Emil Pierre; (second row) Helen Sims, Dolores Waldorf, Anna Abel, Nettie Dow, Marion Bocks Beall, Olive Rowley, Anita Quinn, Charles Baer, Charles Bocks, Webster Baer, and George Becker. (Courtesy J. D. Williams family archives.)

The Cupertino Historical Society was first organized by Louis Stocklmeir on October 9, 1964, as the Citizens Committee for Historical Landmarks but changed its name in 1966. The society operates a small museum with changing exhibits in the Quinlan Community Center and promotes local history by taking a "historical trunk" to classrooms and meetings to educate residents about "the olden days." (Courtesy Cupertino Historical Society.)

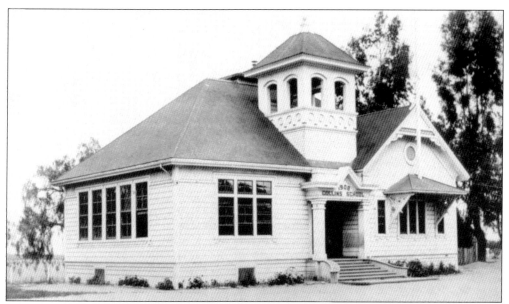

The Cupertino De Oro Club was established in 1921 as a women's club to preserve the old Collins School. The building went up for auction in May 1921 after the consolidation of the four schools into the Cupertino Union School District. J. U. Miner purchased the former school for $1,800 and agreed to resell the building to the ladies. The club officially took over the title on January 17, 1922. (Courtesy Cupertino Historical Society.)

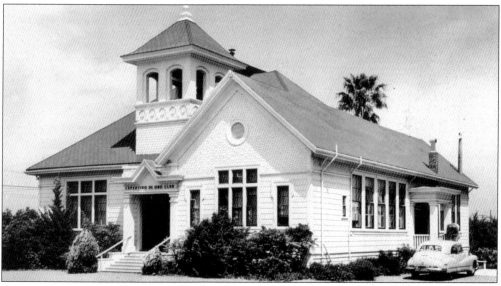

Seventeen women sat on the steps of the Collins School on May 11, 1921, to organize Cupertino's first social club. The group organized its first entertainment, a dancing and card party held on May 27, 1922, which earned them $73.76. By the time the club's charter was signed, there were 30 members. They bought the building from Mr. Miner for $1,950 in 1922 and paid it off in eight years. They raised $1,711.17 from initiation dues, donations, and a fall festival. Remodeling cost $1,371, for kitchen facilities, plumbing, removal of interior walls, and a new furnace. Other expenses were a $5 war tax and an annual electric light bill for $13.98. The building has been a Santa Clara County landmark since 1974. (Courtesy Butcher family archives.)

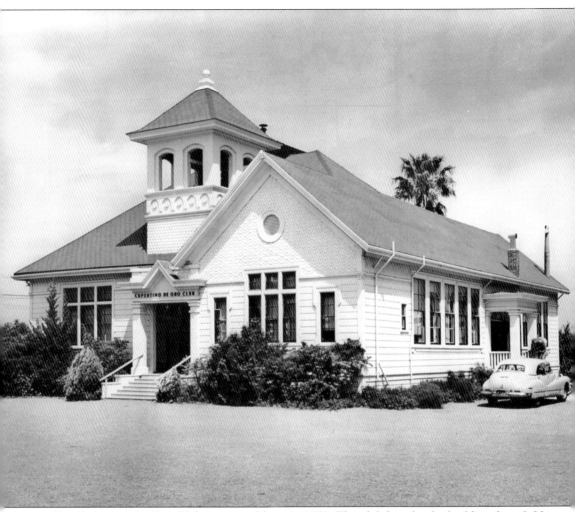

The Cupertino De Oro Club is pictured here in 1950. The club bought the building from J. U. Miner for $1,950 in 1922 and paid it off in eight years. They raised $1,711.17 by initiation dues, donations, and a fall festival. Remodeling cost $1,371 for kitchen facilities, plumbing, the removal of interior walls, and a new furnace. Other expenses included a $5 war tax and an annual electric light bill of $13.98. The building has been a Santa Clara County landmark since 1974. (Courtesy Butcher family archives.)

# *Nine*
# EARLY-20TH-CENTURY BUSINESSES

This modern map of the Cupertino area indicates the roads to both Permanente and the Voss quarry. It also plainly shows Deep Cliff Golf Course, McClellan Ranch Park, Blackberry Farm Picnic area, and Blackberry Farm's nine-hold golf course, all four along Stevens Creek, downstream from the Stevens Creek Reservoir. The darker grey areas are city parks. The paler grey areas are unincorporated properties within the city limiits. (Courtesy Cupertino Chamber of Commerce.)

Rosario Cali came to the United States from Sicily with his brother Sam when he was 18 years old. The pair held a variety of jobs in New York, West Virginia, and California, and operated a store in Daly City, moving to both Willits, California, and Campbell, California, before coming to Cupertino. In 1921, Rosario purchased a 40-acre orchard with his younger brother, Joseph. The orchard was sold in 1922, and Rosario then bought 55 acres of prunes on Regnart Road, where he stayed. (Courtesy Cupertino Historical Society.)

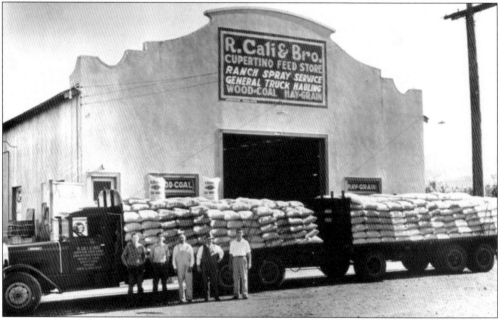

At a time when fruit prices were down, Rosario became the first fruit buyer for the Shuckl Canning Company in Sunnyvale in 1924. Joseph hauled their own fruit, as well as the purchased fruit, in their family truck. The brothers added two more trucks to the operation in 1925. They bought nine acres for a warehouse facility on Stevens Creek Road and Highway 9 in 1928, adding the sale of hay, grain, and farm supplies to the business. Working 18-hour days, the brothers began to prosper. The Bank of America gave Rosario a "Letter of Credit," and he actually doubled the size of the business during the Great Depression. In 1935, the Cali Egg Producer was a popular product. At Christmas time, Cali began putting a Christmas tree on the highest point of their building, eventually crowning the big grain elevator, 300 feet up. It became a landmark that people appreciated. (Courtesy Cupertino Historical Society.)

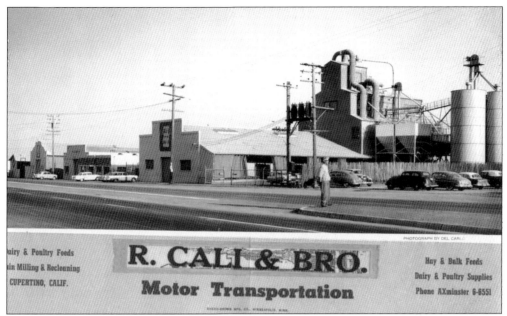

On November 17, 1944, the biggest fire in Cupertino nearly wiped out Rosario Cali's business, destroying the entire feed mill, retail store, and main office. That same day, he made arrangements for the manufacture of feed for his customers. By 1946, the most complete and up-to-date feed mill with the latest machinery began operation, producing top-quality feeds for poultrymen and dairymen. Incorporated in 1947, it became a million-dollar business. (Courtesy Cupertino Historical Society.)

Rosario Cali died in 1961 at age 76. In 1963, Cali and Brother had sales in excess of $3 million. It had 55 truck tractors and 100 pieces of truck equipment and employed 100 people in the 26-acre business. As residential development began to take over the town, agriculture was soon crowded out of Cupertino. In 1988, the mill was taken down and shipped to the Philippines, and the remaining buildings were demolished in 1989. (Courtesy Cupertino Historical Society.)

In 1924, a group of 26 Chinese nurserymen formed the Chinese Flower Growers Association. By the late 1950s, there were six Chinese families with thriving flower businesses in Cupertino. Marshall Mok, a Cupertino flower grower, remembered buying five acres for $4,000 in 1957. (Courtesy Cupertino Historical Society.)

Ernest and Lillian Uenaka were florists before World War II, but they opened Cupertino Nursery in 1948, offering landscaping services, koi fish for ponds, and a florist shop. In 1959, the couple's son Itsuo took over the business, becoming a leader in the nursery industry. The nursery closed in the early 1990s. Itsuo Uenaka now keeps busy with various historical society, Rotary Club, and other civic functions. The Cupertino Chamber of Commerce designated him Man of the Year in 1997. (Courtesy Cupertino Chamber of Commerce.)

Taro Yamagami, a second-generation Japanese-American, grew up in the valley. In 1948, Taro purchased two acres from the Regnarts on Highway 9, opening a produce market for travelers to Santa Cruz and the beaches. In the late 1950s, he started a nursery and landscape design shop, which was in great demand as housing grew. The Oka family took over the Yamagami Nursery in 1963 and is still operating it today. (Courtesy Cupertino Historical Society.)

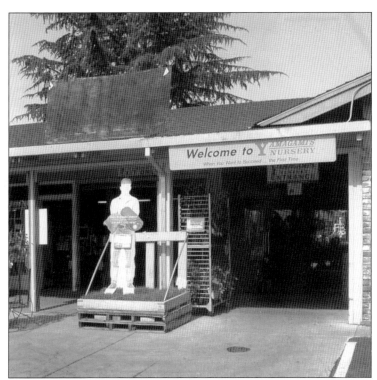

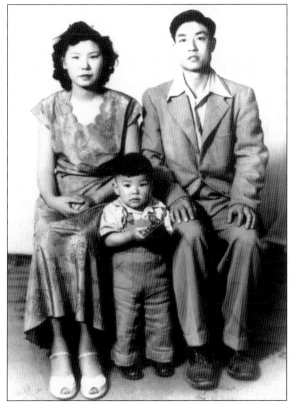

Born in 1917 in Watsonville, Mas Hirata married Tee Nishiyama in the San Jose Buddhist Church in 1940. After the war, Mas went to work for the Fremont Union High School District; he was in charge of the landscaping at Cupertino High School, then became supervisor of the warehouse and field for the district until his retirement at the age of 62. Tee Hirata worked at the Richard Woelffel Company as a bookkeeper for 24 years. (Courtesy Cupertino Historical Society.)

This 1907 wedding picture shows Paul Mariani and Victoria Svilich, with best man Jack Mariani and maid of honor Antoinette Svilich. Paul Mariani followed his girlfriend's family from their native Yugoslavia in 1902. He became a cooper's apprentice in San Francisco, riding his bicycle for half a day or catching a train to see Victoria in Cupertino on his days off. He lost everything in the 1906 earthquake but still married the girl in 1907.

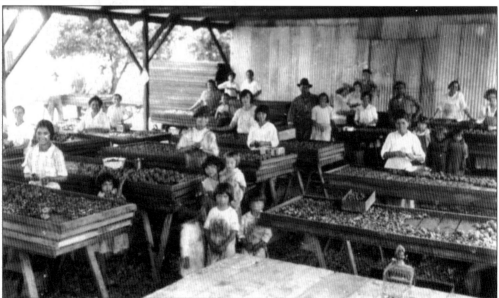

In 1913, Paul Mariani began buying green fruit. By 1916, he had a Model T Ford and his business was prospering. It seems that he had a knack for predicting crops . . . but not weather. In September 1918, it rained six inches in 24 hours, ruining the crops and leaving Mariani penniless and in debt. But the following year, the crops were so good that he was able to pay off all he owed. (Courtesy Cupertino Historical Society.)

Mariani's process was to sulfur the apricots, then place them in a dehydrator at a temperature of 160 degrees Fahrenheit for 24 to 36 hours rather than three weeks in the sun. They came out a rich, even color. Three tons of green fruit made one ton of dehydrated fruit, compared with five tons of green fruit yielding one ton of sun-dried fruit. It cost $12 to dehydrate a ton of green fruit while sun-drying cost $20 per ton. (Courtesy Mary Lou Lyon.)

This worker fills boxes of prunes at Mariani's line. Mariani exported prunes to Europe in the 1920s, but as Hitler came to power, he decided to concentrate on the domestic market. The bottom layer of fruit is placed by hand, while the remaining layers are machine packed; the boxes are then stapled shut and shipped to hotels, hospitals, and schools. (Courtesy Mary Lou Lyon.)

After World War II, Paul Mariani Jr. worked with the University of California's Department of Food Technology and developed the first commercially dried prunes that were soft and ready to eat. The Marianis were the first to produce a ready-to-eat prune in a transparent bag. Recently, someone got the bright idea to label them plums instead of prunes. All prunes are plums, but not all plums are prunes. (Courtesy Mary Lou Lyon.)

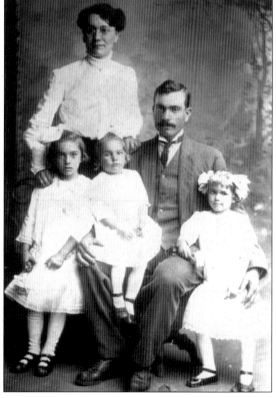

While Paul Mariani had only three years of schooling, his daughter Winifred became a schoolteacher, daughter Irene a librarian, and daughter Mathilda a partner in the Mariani Packing Company. Paul Jr. graduated from Cupertino Grammar School, Fremont High School, and UC Davis with a degree in horticulture. He added an MBA from UC Berkeley and Santa Clara. Mariani died at 81 in 1966, and the Mariani Packing Company moved to Vacaville in 2002. Here are the Marianis with their three girls. (Courtesy Cupertino Historical Society.)

During Prohibition, Mariani renovated one of his storage barns and created a recreation club for youth called the Napredak Club. When the Japanese-Americans were released from their relocation camps after the war, Mariani hired them and provided them with shelter by building Quonset hut housing on his property. He never had an office but instead walked around the plant talking to the workers and even taking their places for a few moments so they could rest. (Courtesy Mary Lou Lyon.)

Pictured here are four generations of the Mariani family: great-grandmother Irene Svilich, grandmother Victoria Svilich Mariani, mother Mathilda Mariani Sousa, and children George and Marian Sousa. (Courtesy Cupertino Historical Society.)

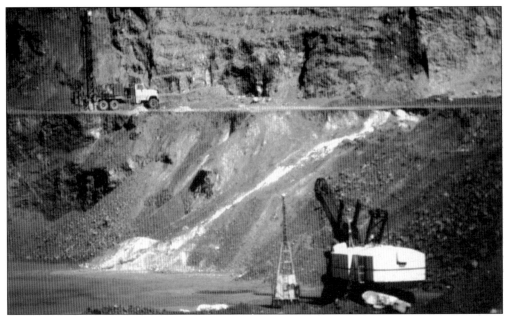

This is the Permanente Quarry. The Kaiser Cement Corporation began in 1939 when Henry J. Kaiser won the bid to supply the cement, sand, and gravel for Shasta Dam. He had no plant at the time, just an option on a limestone deposit overlooking Permanente Creek near Cupertino. He built the two-kiln plant in nine months, arriving at the dam site with the first bags of cement just in time. (Courtesy Mary Lou Lyon.)

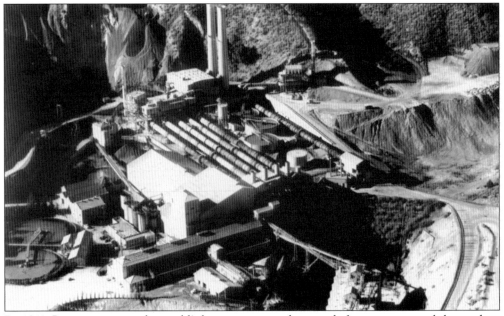

By 1941, Permanente was the world's largest cement plant, with four wet process kilns and an annual capacity of 40,000 tons of cement. During World War II, all skilled workers in the plant were called up by the military, so their wives, sisters, mothers, and girlfriends filled their places. They made production records and then broke them to support the war effort. (Courtesy Mary Lou Lyon.)

During World War II, 99 percent of Permanente's massive output went to the federal government. Kaiser pioneered the use of bulk cement in oceangoing vessels. It was faster to ship bulk than in sacks, saving both time and dollars. The company owned its own line of barges and two steamships, the SS *Permanente Silverbow* and the SS *Permanente Cement*. (Courtesy Mary Lou Lyon.)

Homestead High School students inspect a cement truck. After the war, the demand for both residential and commercial buildings was up, and production was running at 1.1 million tons of cement a year. A fifth kiln was added in 1951 and a sixth in 1956, increasing production 20 percent. An aggregate plant was opened the same year to supply rock for highway construction. (Courtesy Mary Lou Lyon.)

The wet process used half a million gallons of water a day, carrying the slurry through the kilns and releasing steam. After the 1973 oil embargo, heating the water along with the minerals was too costly. New technologies available in the late 1970s made it cost effective to change the method, so a $112-million program was launched to replace the six kilns with a single dry-process method that could burn coal, fuel oil, or natural gas. (Courtesy Mary Lou Lyon.)

Today Hanson PLC of Britain runs the 3,600-acre Permanente site. The 90-foot-high, pre-blend dome can store 54,000 tons of raw material at one time. Two mills, each 5,800 horsepower, crush the rocks to smaller sizes. The single kiln is 250 feet long, 16 feet in diameter, and burns at 2,700 degrees Fahrenheit. It takes the material only 15 to 20 minutes to travel through the kiln. The finish mills grind the clinker with gypsum, producing cement. Permanente today supplies one-third of all cement used in Northern California. (Courtesy Tim Peddy.)

David Voss and his 140 employees are active members of the community. David is a longtime Lions Club member and an ardent supporter of Via Rehabilitation. One of their activities is the annual Lions Club Fish-A-Thon, which benefits blind children and the disabled. This annual event takes place at a large pond in the quarry that David stocks with over 2,000 trout donated by the California Department of Fish and Game. (Courtesy Cupertino Chamber of Commerce.)

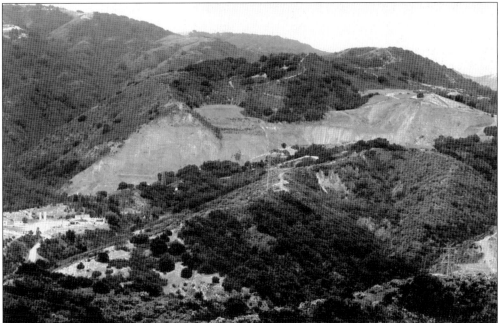

This view shows Voss Quarry from Montebello Road. About 100 children attend the Fish-A-Thon there each year, with many Lions Club members coming to help them catch a fish. The Stevens Creek Volunteer Fire Department and the Santa Clara County Central Fire Department bring trucks for the children to climb on, Smoky the fire prevention bear, and a spotted fire dog. David Voss was named Citizen of the Year in 1997 by the Cupertino Chamber of Congress. (Courtesy Tim Peddy.)

The Cupertino–Monta Vista Improvement Association was formed on July 17, 1954. Some 121 people gathered to listen to the fact-finding committee report. R. Ivan Meyerholz, chairman of the group, strongly urged incorporation. Cupertino Improvement Club members in 1950 are, from left to right, (first row) Vernon Childs, Hubert McDaniel, Anthony Lillo, and Louis Stocklmeir; (second row) Blanche Woeffel, Rudy Frates, Peter Camarda, and Norman Nathanson; (third row) Chester Damico, James Nudelman, John Saich, and Warner Wilson. (Courtesy Cupertino Historical Society.)

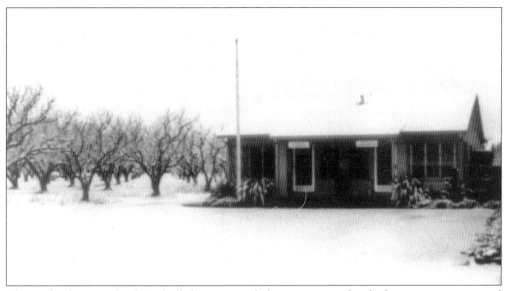

This early photograph of city hall shows it nestled next to an orchard of apricot trees, covered by a very unusual snow in 1962. This is one of the remaining apricot orchards of that time next to 10321 Saratoga-Sunnyvale Road. The building still stands, but there is not a tree in sight in 2006. (Courtesy Cupertino Historical Society.)

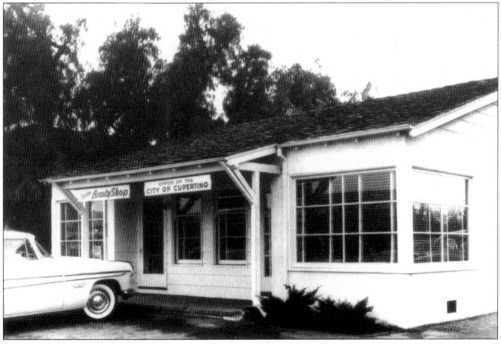

The first city hall was established in a room in the fire station on Stevens Creek Boulevard with hours from 10:00 a.m. to noon. Later the city leased half of a building containing Ann Zarko's beauty shop and remained at that site until May 28, 1959, when the building was moved to a site about 100 yards south of Rodrigues Avenue at 10321 Saratoga-Sunnyvale Road. (Courtesy Cupertino Historical Society.)

The site for the new city hall was six acres of cherries, purchased for $18,000 an acre. Before the buildings were erected, they sold the cherry crop for a profit of $1,495. This photograph shows the current city hall under construction in 1965, with the Cupertino branch of the Santa Clara County Library in the distance. (Courtesy Cupertino Historical Society.)

The dedication of the completed city hall building was in November 1966. Since then, it has been remodeled, the first library scrapped, and a new huge Cupertino branch of the Santa Clara County Library built as well as a new building to hold larger events, Cupertino Community Hall. (Courtesy Tim Peddy.)

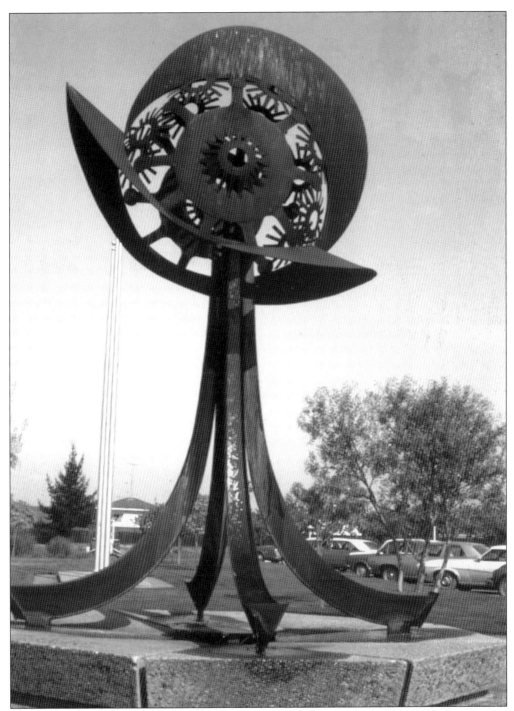

This Spanish-style morion, a symbol of the soldiers with De Anza who first camped at Stevens Creek, was placed in front of the new city hall during the bicentennial celebration. This sculpture was commissioned in the 1970s and restored in 2006. With further construction in the civic center, it has been moved to the corner of city hall at Torre and Rodriguezs Avenues. The ciy flag also sports the symbol of the Spanish morion.

# BIBLIOGRAPHY

Connor, Ann W. and Ethron Young, eds. *The Trianon Waits*. Cupertino, CA: California History Center, 1973.

Douglas, Jack. *Historical Footnotes of Santa Clara Valley*. San Jose, CA: San Jose Museum Association, 1993.

Foote, H. S., ed. *Pen Pictures of the Garden of the World or Santa Clara County, California*. Chicago, IL: Lewis Publishing Company, 1888.

Garate, Don. *Juan Bautista de Anza National Historic Trail*. Southwest Parks and Monuments Association, U.S. Government Printing Agency, 1994.

Mehren, Leslie. *From the Ground Up: How Business Grew in Cupertino*. Cupertino, CA: Cupertino Historical Society, 1998.

Rambo, Ralph. *Ralph Rambo's Pen and Inklings: Nostalgic Views of Santa Clara Valley*. San Jose, CA: The San Jose Museum Association, Rosicrucian Press, 1984.

Quackenbush, Margery, ed. *County Chronicles*, Vol. 9. Cupertino, CA: Local History Studies, California History Center, 1975.

———. *Santa Clara County and Its Resources; Historical Descriptive, Statistical; A Souvenir of the San Jose Mercury, 1895 (Sunshine, Fruit and Flowers)*, San Jose Mercury, San Jose, CA.

Sawyer, Eugene T. *History of Santa Clara County California with Biographical Sketches of the Leading Men and Women of the County Who Have Been Identified With Its Growth and Development from the Early Days to the Present*. Los Angeles: Historic Record Company, 1922.

Schultz, Linda Sharman. *Buckeye and Brodeaias: The History of a One-Room Schoolhouse*. Cupertino, CA: Cupertino Historical Society, 2000.

———, ed. *Cupertino Chronicle*. Cupertino, CA: Cupertino Historical Society, 2002.

Sullivan, Charles L. *Like Modern Edens: Winegrowing in Santa Clara Valley and Santa Cruz Mountains, 1798–1981*. Cupertino, CA: California History Center, 1982.

*Thompson and West New Historical Atlas of Santa Clara County, California Illustrated, 1876*. San Jose, CA: Smith and McKay Printing Company, 1973.

Warren, Walter, ed. *The Diary of Cora Baggerly Older*. Cupertino, CA: California History Center, 1971.